TOWERING MIRRORS, MIRRORING TOWERS

Photographs of Urban Reflections

David Weinberg

Preface by Carol A. Willis, The Skyscraper Museum
Foreword by Rod Slemmons, Chicago Museum of Contemporary Photography

Glitterati
INCORPORATED

New York, New York

DEDICATION

For my wife Jerry.

ACKNOWLEDGMENTS

Even a labor of love requires the help and support of others. I had such help in spades.

Thanks to:
Tim Arehart, who helped put my thoughts into a language that was interesting and understandable. Susan Grode, an entertainment lawyer who offered me good legal and practical guidance. Marta Hallett, my publisher, who believed in the book from the start and has continued to be a source of creative ideas. Belinda Hellinger, who drove the layout process and was a well of ingenuity. Amy Nieves, for help in so many ways and constant encouragement. Cassi Ott, a fine graphic artist, technical advisor, and friend. Tom Pagels and Greg Saunders and The Hyatt Regency Chicago for being the first to exhibit my reflections. Howard Schatz, for early advice and guidance, which turned out to be "right on." Lewis Weinberg and Sylvia Radov, my parents who hooked me on art through their passion for it.

First published in the United States of America in 2006 by

Glitterati Incorporated
225 Central Park West
New York, New York 10024
Glitterati@verizon.net
www.GlitteratiIncorporated.com

Copyright©2006 David Weinberg
www.d-weinberg.com

First edition, 2006
Library of Congress Control Number: 2006928711
Hardcover ISBN 0-9777531-2-3

Design by Belinda Hellinger Fornasieri

Printed and bound in China by
Hong Kong Graphics & Printing Ltd.

10 9 8 7 6 5 4 3 2 1

CONTENTS

PREFACE

Chicago is a city of towers, second to New York in number, but first in most minds when it comes to skyscraper history. After the Great Fire of 1871, an ingenious generation of architects and engineers pioneered techniques of design and construction that gave rise to the "Chicago frame," a skeleton of steel columns and beams that allowed buildings to stretch first to ten stories, then to more than twenty by the 1890s. The strong metal cage opened the exterior wall to the opportunity for expanses of glass, and a new form of commercial architecture was born that would define American cities for the next century. The need to bring daylight deep into the interiors of early office buildings meant that windows grew to occupy as much of the facade as possible, until they were far too heavy to open. The "Chicago window" was the answer: a large fixed central pane framed by double-hung sash that is still visible today throughout the Loop. In old-fashioned masonry buildings, the window-to-wall ratio was 1:3; in some early Chicago skyscrapers, those numbers reversed.

Modernist architects spent the next hundred years pursuing an ideal of all-glass towers. After World War II, technological advances in welded steel frames and curtain-wall systems allowed style arbiters such as Mies van der Rohe or the corporate firm Skidmore, Owings & Merrill to realize grids of metal and glass of unprecedented elegance in high rises such as 860 and 880 Lake Shore Drive and Inland Steel. By night a lantern glowing from within, by day a screen for the bouncing play of urban light, the glass box became the basic module of the modern city. As Chicago's skyscrapers soared ever taller in the late 1960s and 70s in structures such as the John Hancock Building and Sears Tower, though, the vast acreage of tinted glass began to look monotonous. In the 1980s and 90s, mirror glass represented the new fashion—sleek, slick, and visually impenetrable as the bug-eye shades of a highway patrolman.

David Weinberg focuses on reflections in the gleaming glass towers of recent decades. He includes some refined classic modern facades, with their bays of vision glass and opaque shadow-box spandrels, but the most free-form of his images dance on the squares of pillowed mirror-glass that has been scorned by some critics as shrink-wrapped architecture. For Weinberg, the surface functions not as facade, but as an active screen, as in cinema. Many images are tight close-ups that take a small area to reflect a larger urban world. Does it matter that the world is Chicago? No, and yes. The photographs of Dallas's curlicue towers are some of the most raucous of his "circus" images because they are pulled back, as that more spread out city allows; likewise Sarasota. But the complex, crowded, storied Chicago is as much an inadvertent as intentional subject in the majority of Weinberg's photographs. Its history playing on the towering mirrors is indelible. If other people find the modern city monotonous or impersonal, Weinberg shows us, they are just not looking closely enough.

Carol A. Willis
Director, The Skyscraper Museum
New York City

FOREWORD

David Weinberg is not playing an easy game here. Abstraction and photography have had an uneasy relationship. This is mainly due to our ingrained need to treat photographs as messages from the clear, focused, unadulterated world of visual experience. The number of artists using photography who have succeeded in creating convincing non-literal imagery is not huge, but important—Antonio Bragaglia, Andre Kertész, Alfred Stieglitz, Bill Brandt, Francis Bruguière, Man Ray, Lazlo Maholy Nagy, Aaron Siskind, Harry Callahan, Henry Holmes Smith, Lotte Jacobi, and others. David Weinberg's extensive experiments have given him an opportunity to join that circle.

It is important to note, however, that there was a give-and-take between photography and American Abstract Expressionist painting—in the relationship between photographer Aaron Siskind and painter Franz Klein, for example. But the general public continues to resist the idea that photography is capable of producing something that doesn't have a recognizable visual/experiential equivalent.

In that context, it is interesting to note that photographer Alfred Stieglitz called his abstract cloud experiments made in the late twenties "equivalents," explaining that his hope as an artist was that the cloud shapes would stand in for, or produce, in others, the "equivalent" of what Stieglitz was feeling at the time he photographed them. And, of course, the painters he championed in the 1930s are the ancestors of American AbEx—John Marin, Georgia O'Keefe, Marsden Hartley, and Arthur Dove.

I have generally thought of abstraction as embedded in "straight" photography, and of Stieglitz's hope, or Klein's or Pollack's hope for that matter, of communicating directly and viscerally through shape rather than recognition as being something that lies directly on the surface of what Lee Friedlander, or before him, Robert Frank, or the whole New York School, accomplished. There is an image of the back of a car at the very end of The Americans that contains

a reflection very close to the shapes in Robert Motherwell's painting series, "Elegy to the Spanish Republic." The two images were made within a couple of years of each other.

Another element of David Weinberg's imagery—and an ally in his success at this game—has a different heritage. Working in the 30s and 40s, artists like Lisette Model and Walker Evans invented ways that photography could gain the layers of meaning, and ultimately the respect accorded painting and other art forms. They produced imagery that contained reflections and/or transparencies. Like Weinberg, they worked on window lined streets. This afforded a different axis of abstraction, a movement fore and aft of the surface of the printed, flat photograph. The surface of a window, for example, contains information about what is both behind and in front of the viewer, and blends the two like real time experience blends memory and perception. There is a deciphering that goes on here, but not for the purpose of straight recognition.

"Straight" photography alone has the effect of producing the illusion of a single viewer, a fixed P.O.V., a self. When surfaces melt and shift, like they do so effectively in Weinberg's work, there is an allowance for more than one self walking down the street in the same skin, using the same eyes.

Rod Slemmons, Director
Museum of Contemporary Photography
Chicago

INTRODUCTION

Tall buildings have been a fascination for me since childhood. Growing up in a suburb of Chicago, I was always excited to take family trips downtown. The sight of the skyline heightened my anticipation; I used to watch it first as a bulge on the horizon, then growing and growing until the skyscrapers loomed over us.

Later, working as a Chicagoland business executive, I saw those buildings every day. I never grew tired of them; I loved to find snapshots of urban life mirrored in the shining surfaces of glass and steel. Years later, those reflections of the city—clouds and sunlight, faces and buildings—became the inspiration for this series of photographs. I wanted to capture the places we live and work as I see them: accidental mirrors framing urban scenery in surprising ways, and showing us details and colors we are often too busy to notice.

My goal is to expose the extraordinary in the overlooked through photography. I pursued this object in an earlier series, called L'Esplorazione, which involved photographing abandoned metal objects from scrap heaps at extremely close range to capture the fantastic colors and textures of their rust and patina. Similarly, but perhaps on a grander scale, Towering Mirrors high-lights three cities' unusually reflective light conditions, revealing a seldom-seen carnival of bright colors and distorted, clownish images. No digital manipulation (aside from adjusting contrast and the like) is used: these astonishing images are what you'd see from the street if you found the right angle.

These photographs are about a shift of perception in more than one way. No two people looking at a building see the same skyscraper; they focus on different portions, notice different details. The great power of photography is that it allows the audience to see for a moment through the photographer's eyes. Observing the city in a stranger's camera lens, viewers might notice the marvelous tricks light can play on our senses.

For me, the series represents a refreshing change of perspective. I spent most of my life as a business executive, and I find photographing the exteriors of Chicago skyscrapers an interesting contrast to my earlier experiences working within them. The practicalities of commerce have given way to the appreciation of beauty.

The first section in this series, "Circus Mirrors," is the most whimsical: a collection of twisting, mercurial images that contradict the solid, angular buildings that frame them. They make us smile, even laugh, because they are so different from what we expect to see.

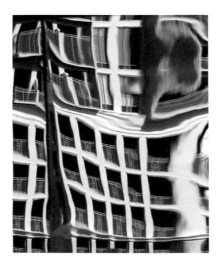

Window glass is seldom perfectly flat; small differences in air pressure make it slightly convex or concave. Imperfect manufacturing causes subtle surface ripples. These irregularities are seldom noticeable when looking through a window, but when looking at reflections the warps become obvious, offering a multitude of images for the observant eye. People who have played with their own distorted images in a funhouse mirror understand the technique: a step forward, a step backward, a step to the right or left and the proportions of an image change completely. A pinheaded giant becomes a bulbous dwarf. A narrow roof becomes a bulging wall.

I call these photographs "clowns," because capturing them is like playing a kind of game with the buildings, as if they are putting on a show for anyone who cares to look. These playful images represent the hidden, humorous side of the quiet stone giants that line our streets.

In "Reflections on the City," I reduced the scale and focused on the reflected images we can find at street level. We usually see the world through the portholes of our eyes, never knowing what it is like to see through someone else's. But these reflections can take us outside our limited perspective, letting us see ourselves as if we were another person. Photographs, too, can show us a different outlook; they filter images through someone else's imagination. Working together, mirrors and photographs open up surprising new windows to the world.

This section features many images shot through semi-reflective glass. At a certain angle, in a certain light, a window becomes a perfect mirror. At other angles, in other lights, a window becomes an imperfect mirror, reflecting and revealing at the same time. A particular focus of a camera lens can find a balance between the images on and behind a window, creating a dreamlike juxtaposition of the two. The result is at once personal and surreal, reminding us of scenes from our daydreams and fantasies. Translucent people float through phantom storefronts; rainbow lights halo half-seen faces; distorted streets stretch to infinity. Glass plays with familiar images, sometimes absorbing them and sometimes tossing them from one shining surface to another, in an interplay that is elusive yet fascinating to capture.

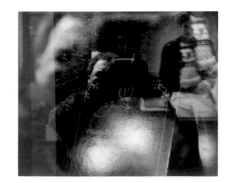

Searching for these shots made me realize how completely reflections surround us. Walking down a city street, shop windows mirror us on one side

and car windows on the other. A glass door in a glass wall gives us ourselves at two different angles. All these mirrors can feed our vanity, and also our curiosity: city-dwellers quickly learn to watch each other unobtrusively in the city's thousand reflections. Mirror-gazing, beyond being just a mode of observation, is a way to find and admire the art of urban life.

The third section, "Window Galleries," is a kind of collaboration between myself and the featured buildings' architects; they planned buildings that would create beautiful reflections, and I set out to try and capture the most stunning effects. These images aim to display the incredible dialogue between modern skyscrapers and their urban surroundings, and to infuse the shapes and colors of each building with a sense of history and design.

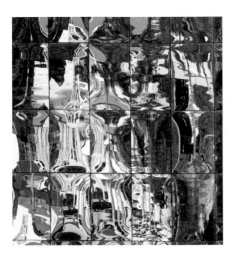

The reflective qualities of skyscrapers are no accident. Glass is popular with architects because it allows skyscrapers to blend with their surroundings by reflecting the city's life back upon itself. Consider the popularity of Chicago's 333 W. Wacker building. Not many people know its name or address, but they know its shape: a long curved front that bends with the shape of the river, reflecting both water and sky in green and blue glass. Or consider the apartments at 860-880 Lake Shore Drive, built by Ludwig Mies van der Rohe, one of the first architects to explore the aesthetics of glass and steel. When they were conceived, critics doubted whether anyone would want to live in "glass boxes," but they became incredibly popular residences.

Especially In Chicago, buildings are most fascinating when we consider just how far the architectural techniques have progressed, finally arriving at the current age of sleek metal and glass. The first buildings to earn the name

'skyscraper' were made in the windy city during the late nineteenth century, made possible by technical innovations and economic realities. Steel allowed the weight of buildings to be transferred to the outer walls rather than supported from below; electricity allowed illumination in the interiors of buildings where sunlight would not reach; and elevators allowed access to high floors where stairs would not be practical. The high prices for land in downtown Chicago after the Great Fire of 1871 forced businessmen to maximize their investments by building up, not out. For the first time, architects had the means and the money to build skyward.

The great glass exteriors captured in this series are a later development. As technology allowed for larger panes of glass to be created, architects began experimenting with using the material in new ways. With steel skeletons supporting the weight of these buildings, the external surface areas could be made almost entirely of glass. This allowed the use of more natural lighting through windows, skylights, and atriums. The Chicago-style window was invented in order to maximize light into tall offices; its large central pane and angled sides allowed it to jut out like a bay window and capture more of the sun's rays throughout the day. Glass exteriors also made skyscrapers more economical, since their energy-efficient properties permitted heating and cooling systems that reduced energy costs and pollution.

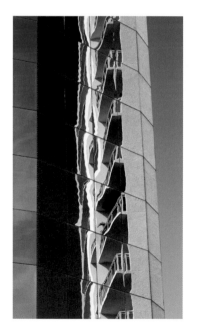

The many colors and patterns of skyscraper windows show different architects' intentions. Black and bronze are best for reflecting heat, while blue and green are easy on the eye and compatible with the visual real estate of the sky. Silver-tinted glass has good reflective properties, as well as an association

with sleek, futuristic design. It is this marriage of function and beauty that makes the skyscraper such an interesting artistic subject.

In the final section, "Through the Looking Glass," I wanted to acknowledge one of the fundamental truths about urban life: it's not the buildings that make a city. It's the people. Swirling through the mirror-lined streets like leaves in a stream, the crowds fill downtown areas with color and motion. A collection of urban photographs would be empty if it didn't include the people that give the buildings spirit.

The photos in this section focus on the interplay between people and places. Some have commuters and vehicles framed by the mirror-panes of their workplaces, surrounded by mirages of glass. In these pictures, the fantastic and the commonplace exist side by side, emphasizing each other by contrast.

Other photos here are more purposefully created, featuring the reflections from a flexible mylar sheet that my assistant and I manoeuvered through the city. These twisted, irrational views of streets are made by bends and kinks in the mylar that evolved as we moved it from place to place. Most of the photos in Towering Mirrors are the result of hunting for reflections; this unit of photographs, on the other hand, is a result of creative artifice. By bringing new reflections into the city, I tried to create my own place among the towering mirrors I set out to capture.

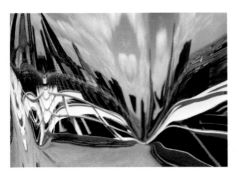

Though they look very different, the interactive element in each type of photo is an artistic connection that puts them in a category together. These are not contemplative shots of skyscraper canyon landscapes, but studies of moving bodies, of people who have crossed over into the city's reflective "fairyland."

I hope this series will inspire people to take an interest in the urban reflections around them. Finding them on your own takes patience and a certain amount of luck. These mirages are teasing and evasive, seen only from a certain perspective from an exact point of view, and only when a building is struck by a precise angle of light at a certain time of day. You might be glancing around idly while sitting at a red light when you spot a kaleidoscope shimmering overhead, or you might spend days craning your neck at windows without seeing anything spectacular. Photographing skyscrapers takes nearly as much alertness as photographing wildlife.

For best hunting, you will of course need to be in a city with a large downtown area. You will also need bright, direct sunlight (cloudy weather is useless for reflections), comfortable walking shoes, and a cheerful indifference to time passing. You will need to wander.

To make the hunt easier, I shoot urban reflections without a tripod. The digital camera I work with features a 400mm telescopic lens of considerable weight. The earliest photographs were taken in Chicago, but later photos were taken on expeditions to Dallas and Sarasota, where I took full advantage of those cities' sunny weather.

For your own reflection-hunting expedition, the most important tool of all is a willingness to see your city with fresh eyes. Forget you're downtown; pretend you're visiting the Grand Canyon. True photography requires us to be more aware of our everyday environment, to take the time to experiment with our perceptions, to open ourselves to the extraordinary.

David Weinberg
Chicago

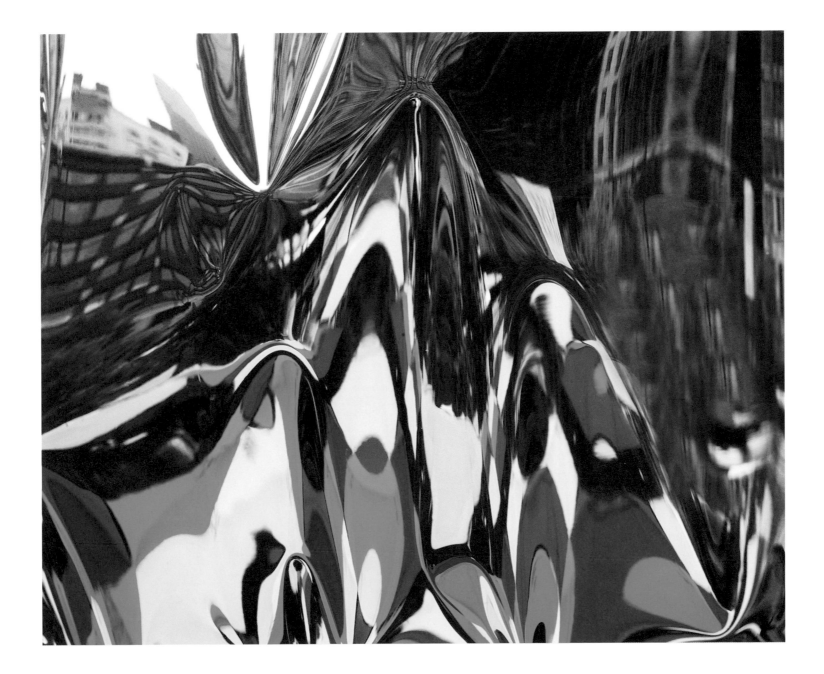

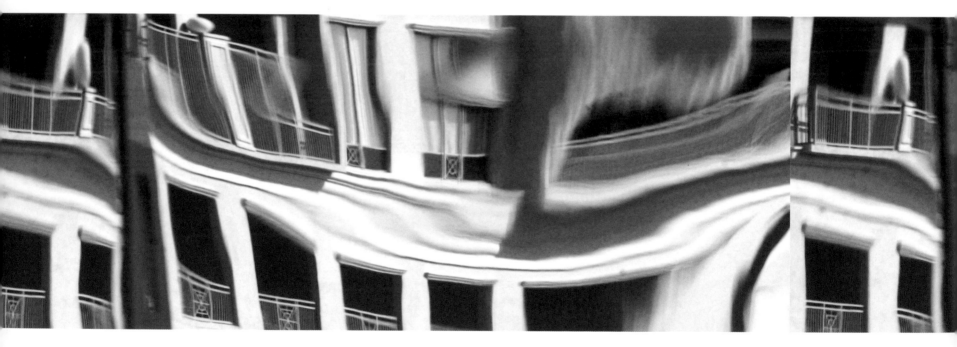

I

Circus Mirrors

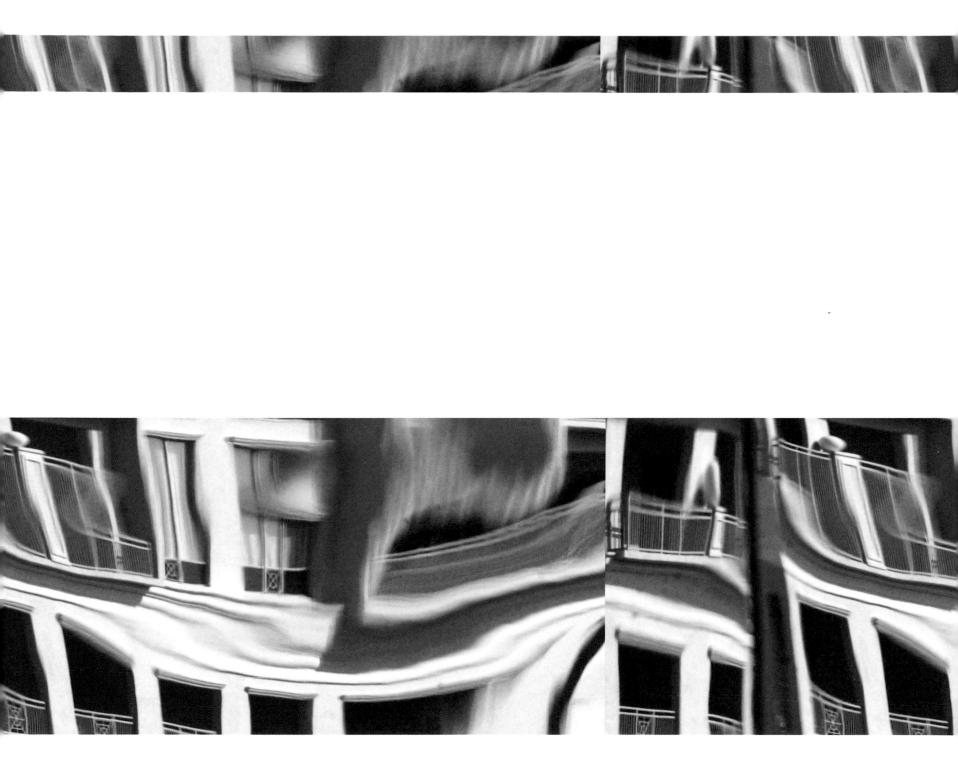

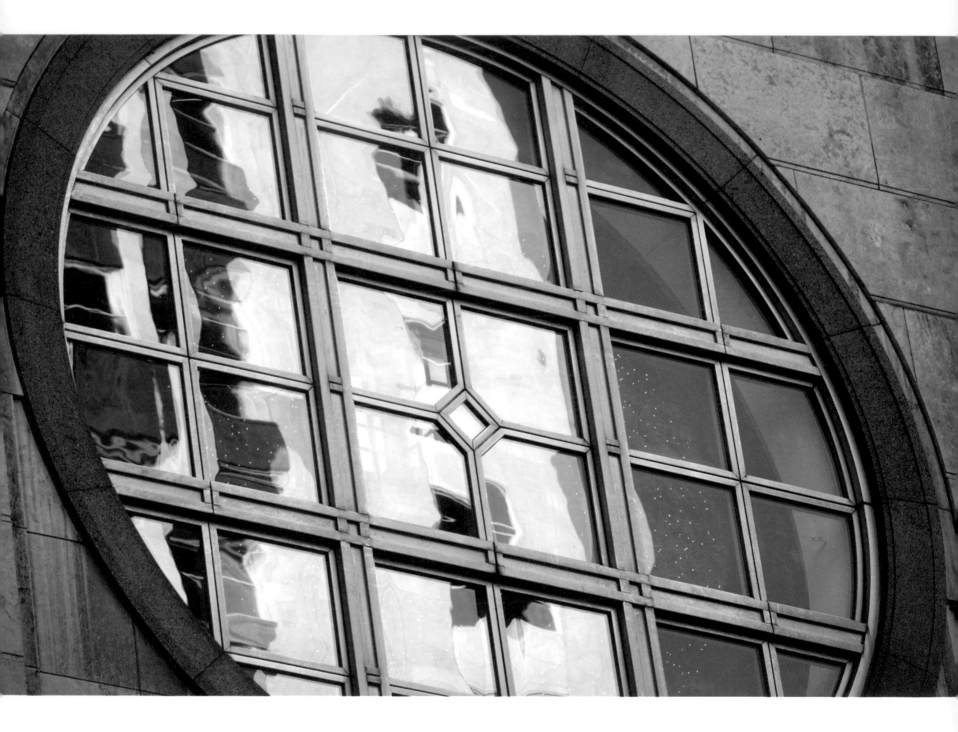

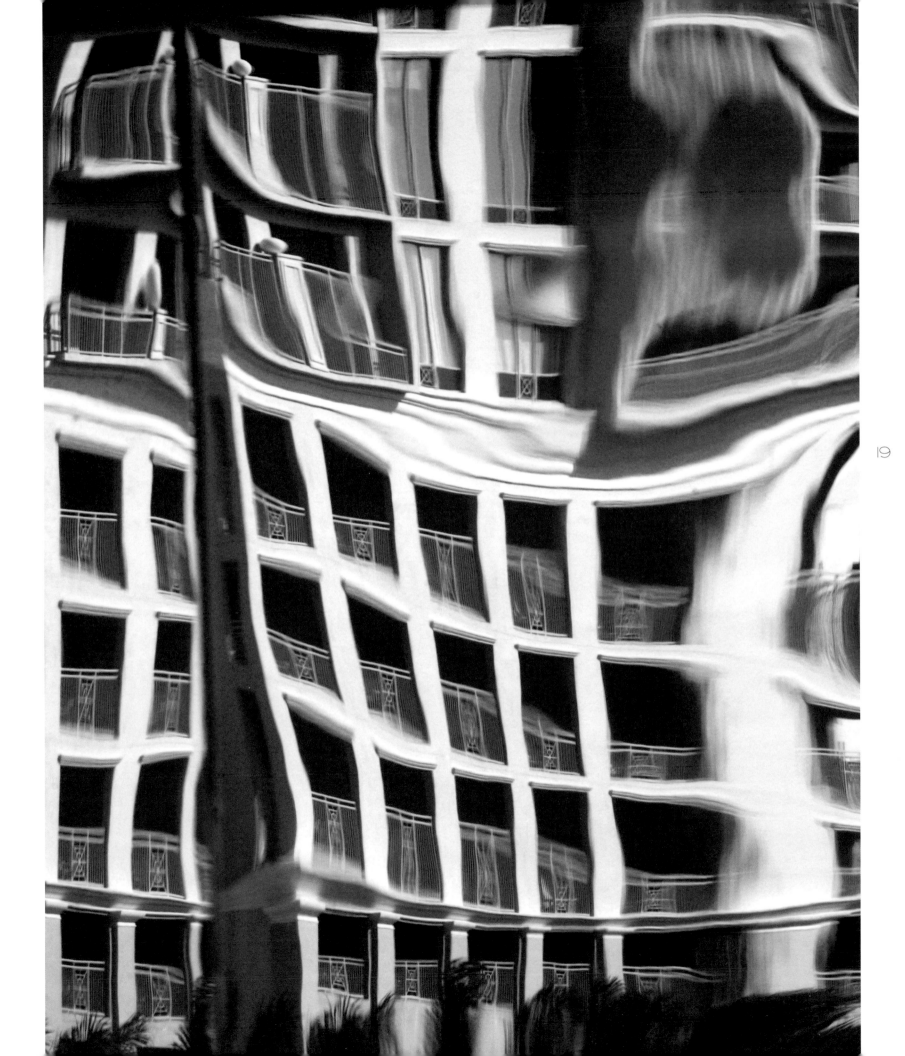

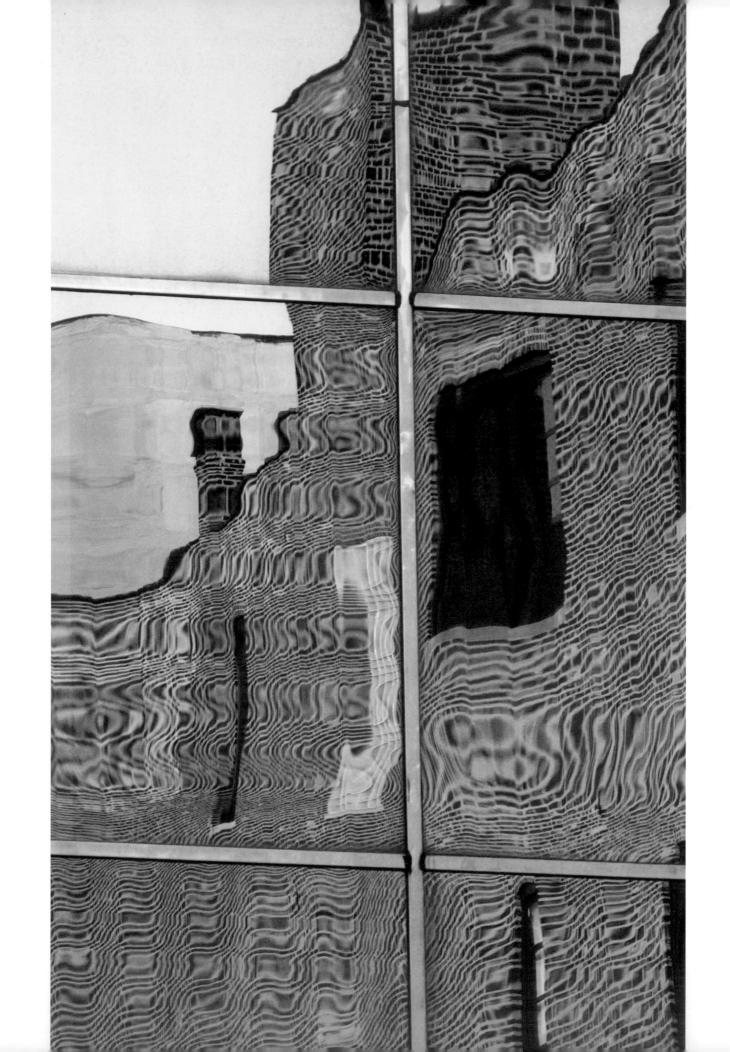

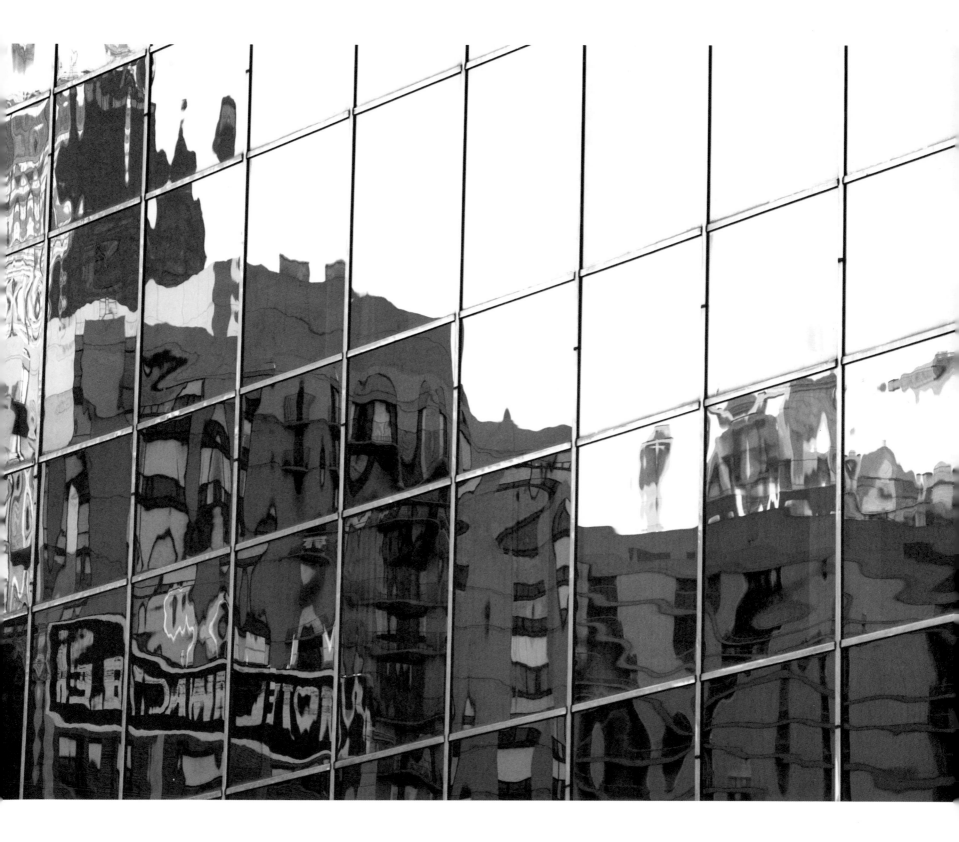

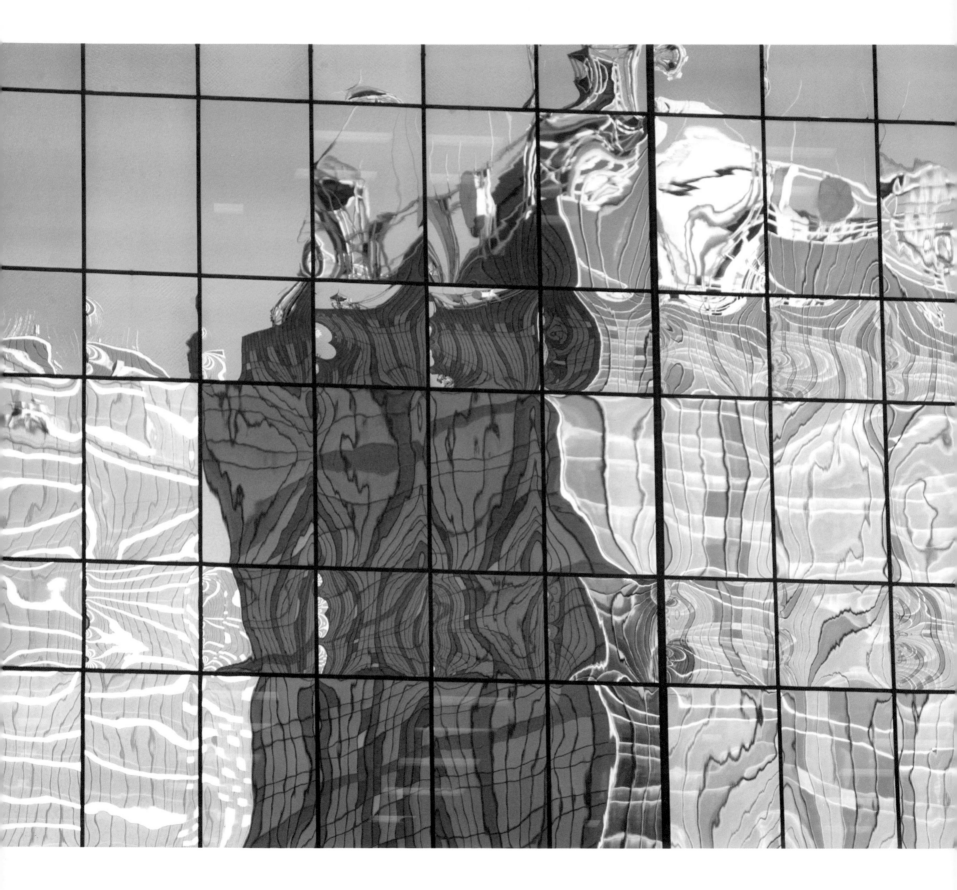

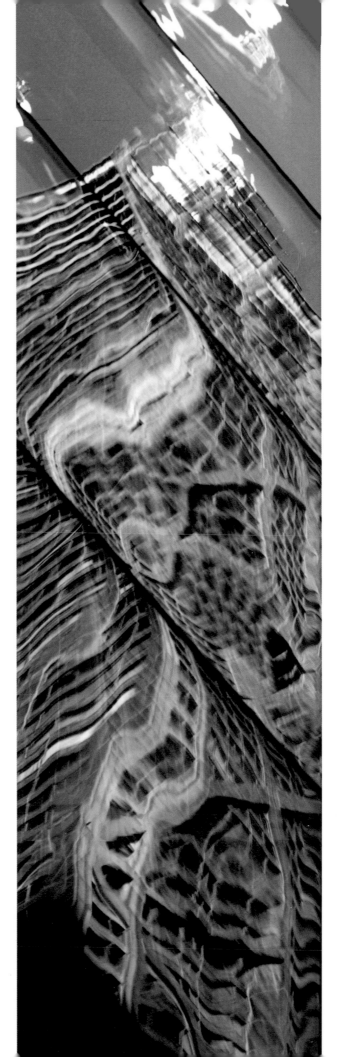

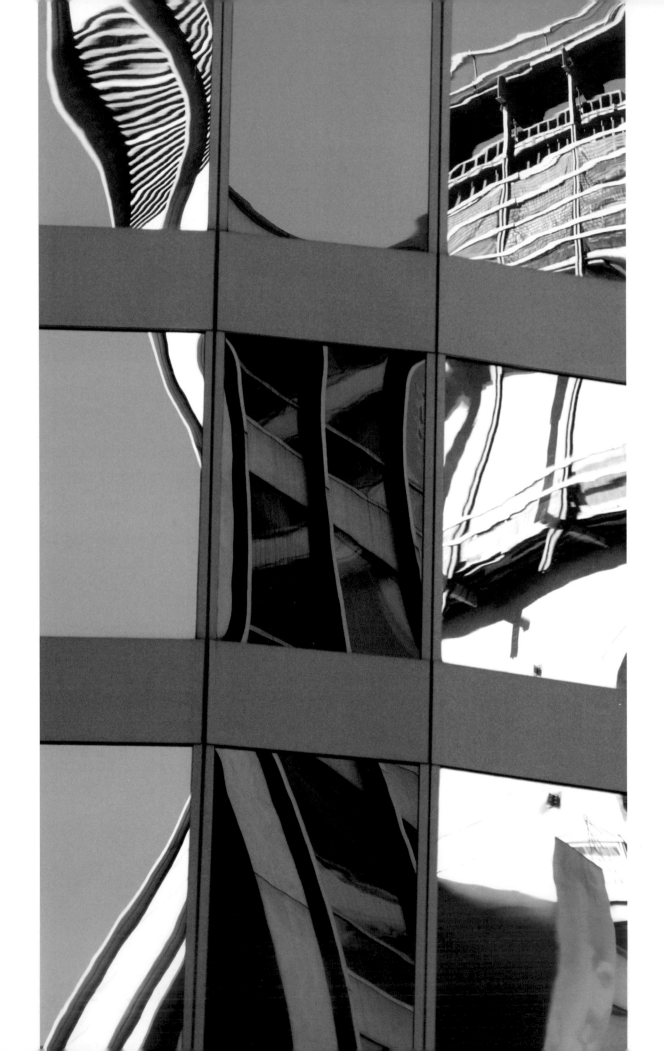

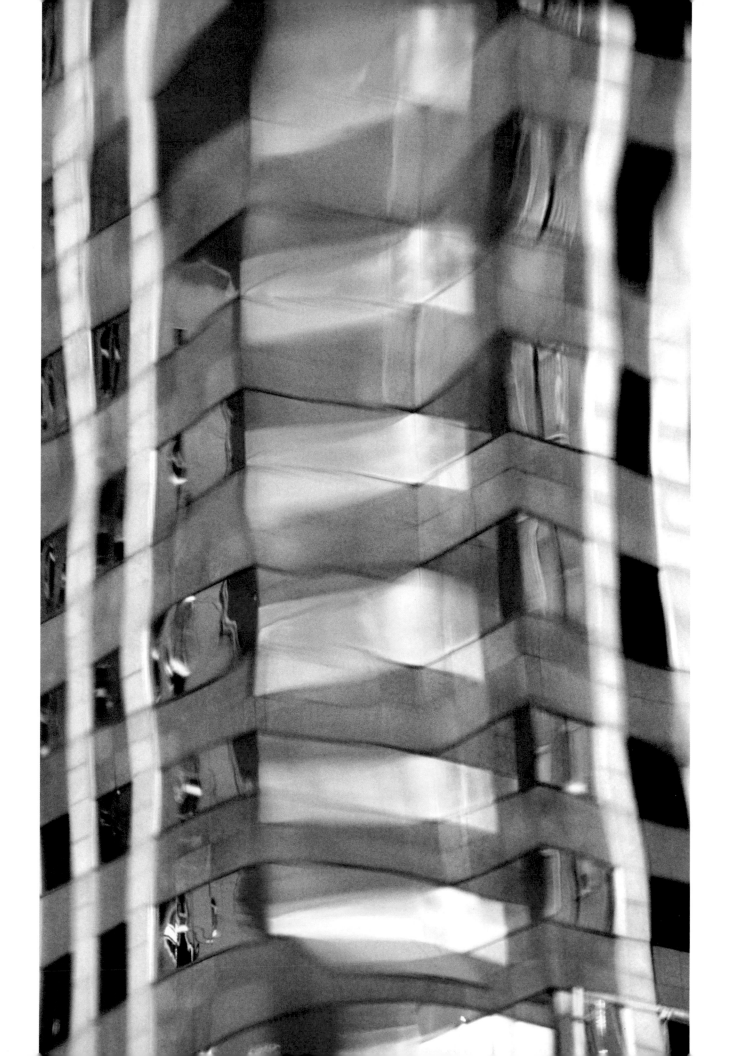

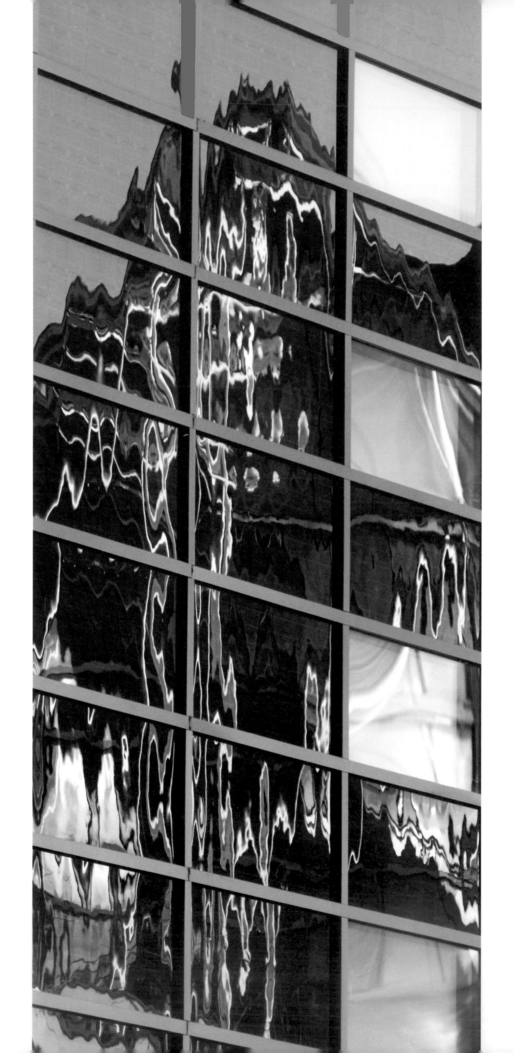

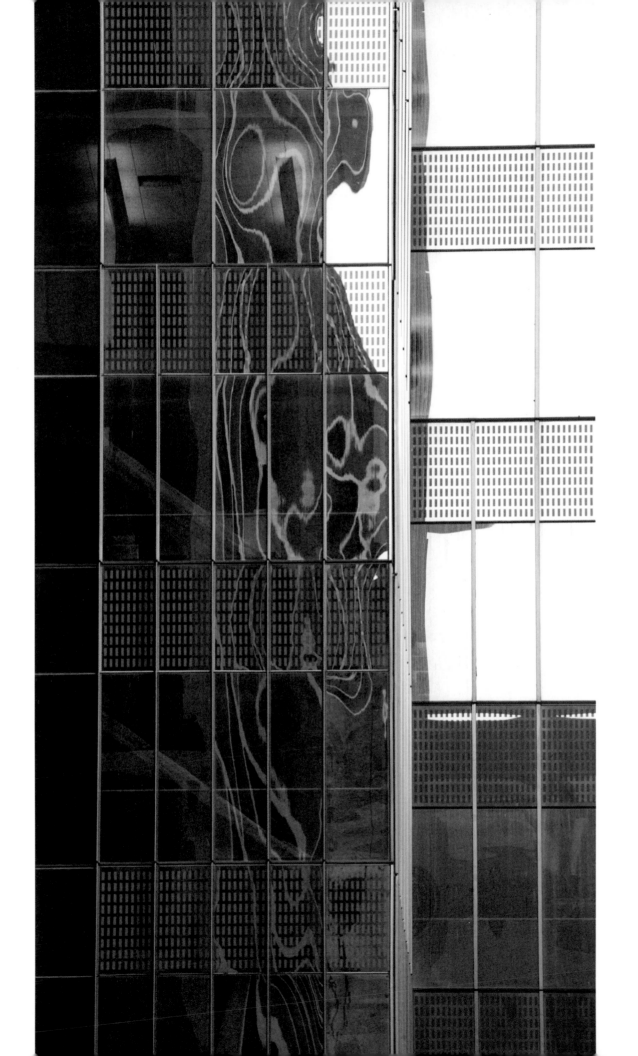

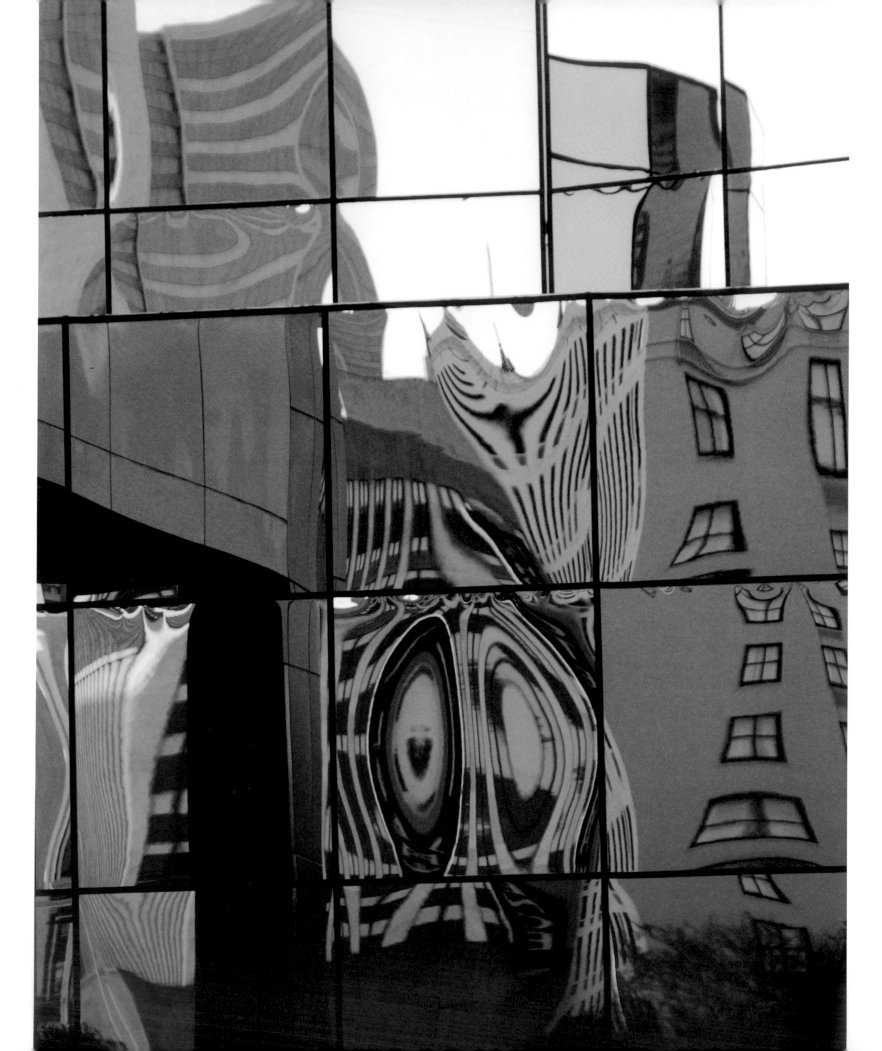

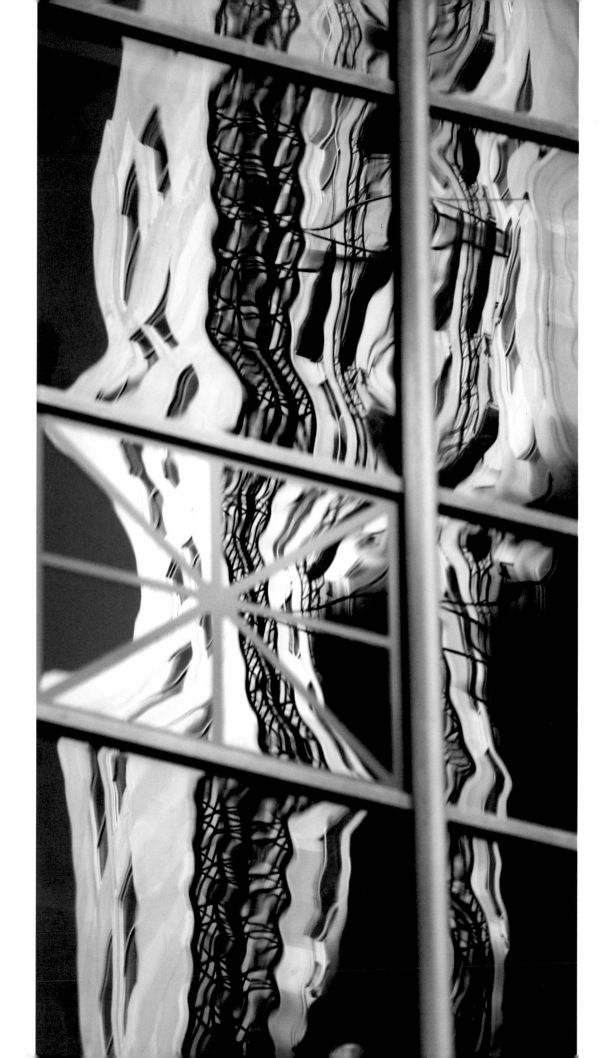

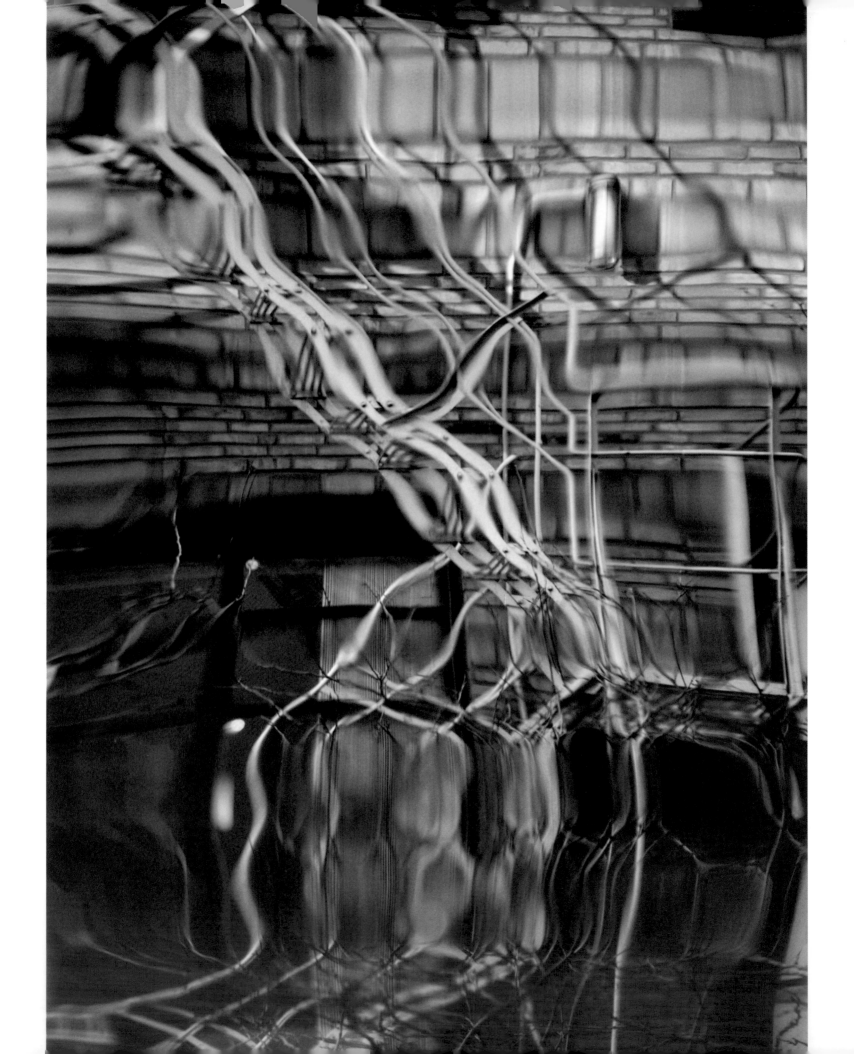

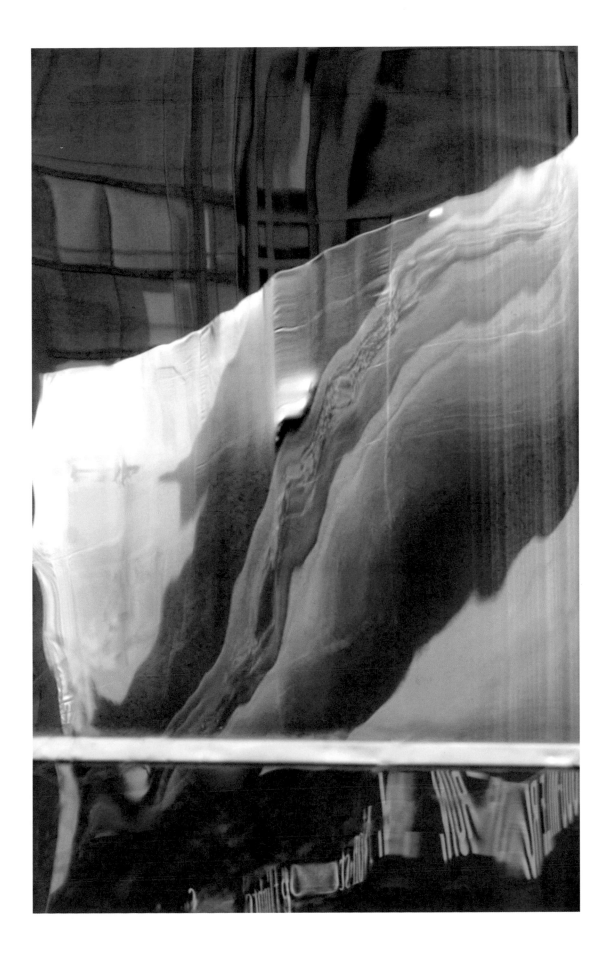

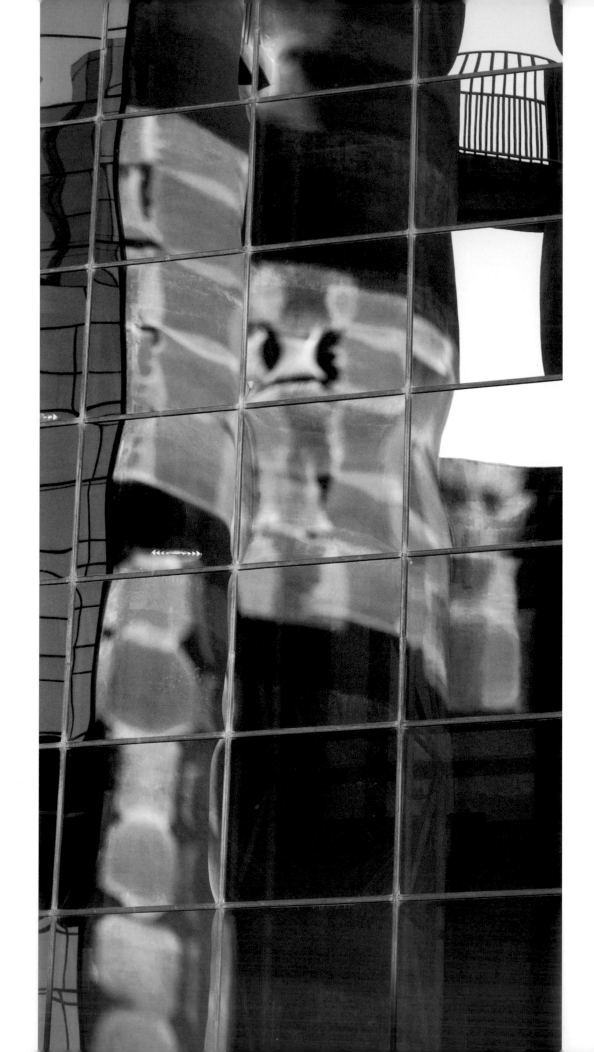

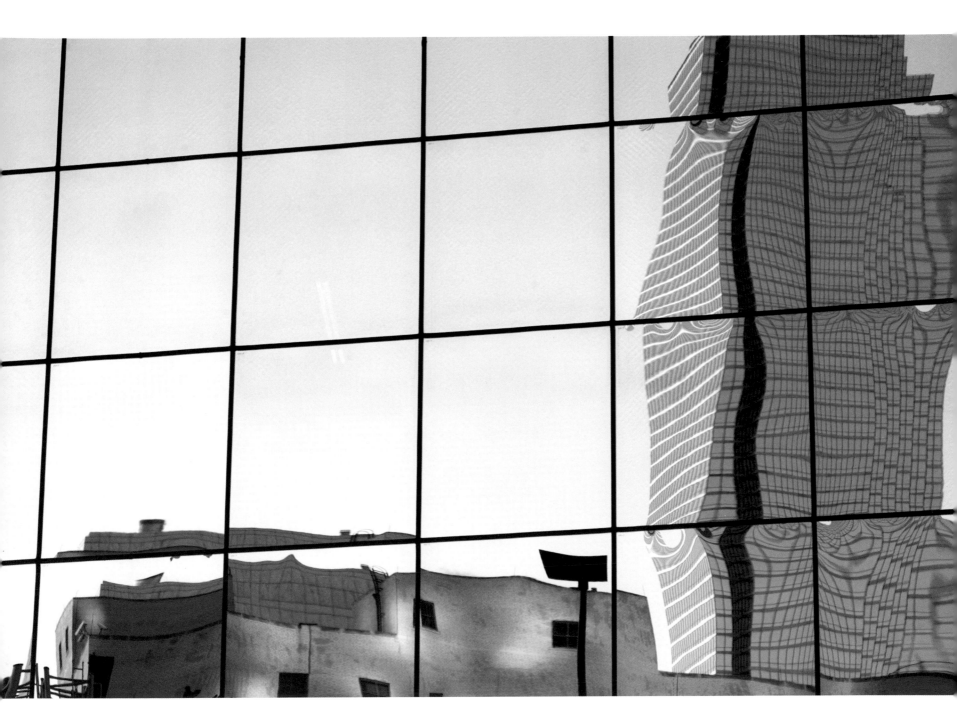

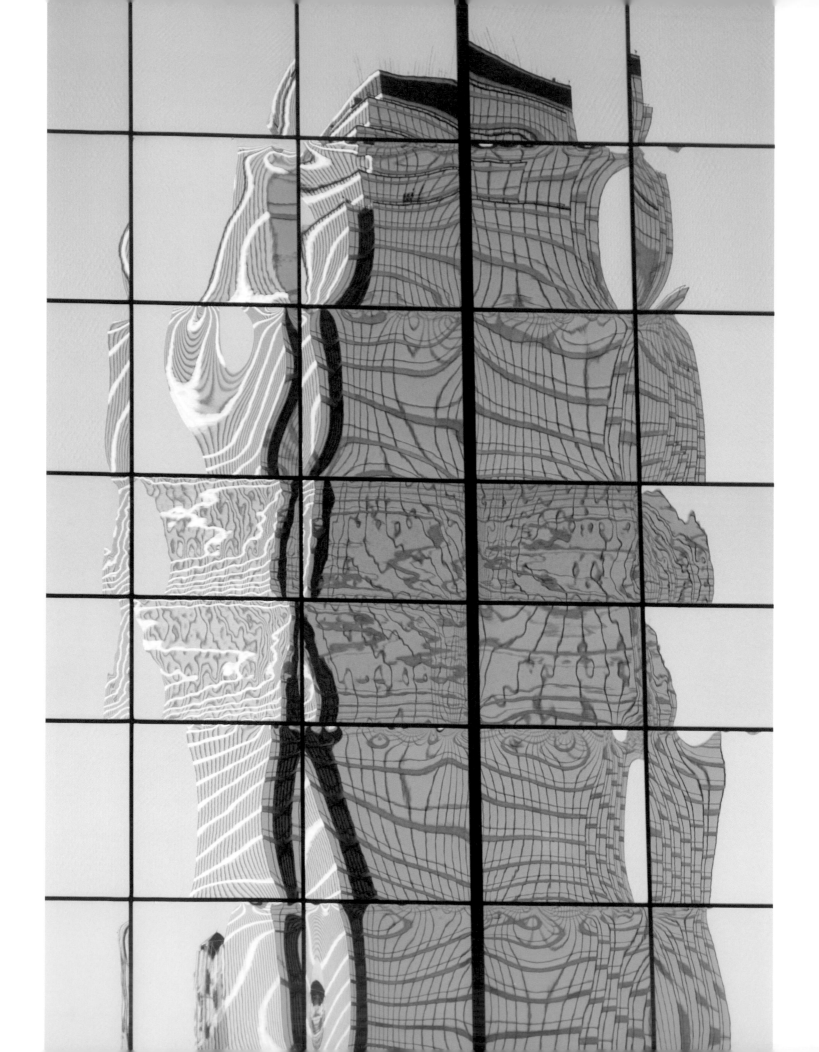

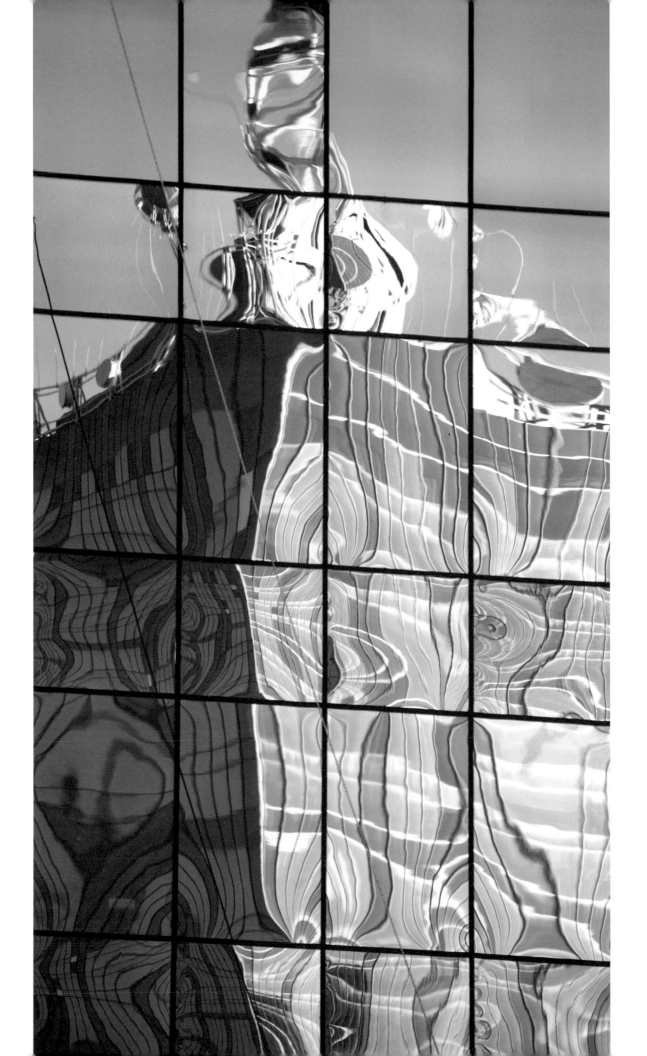

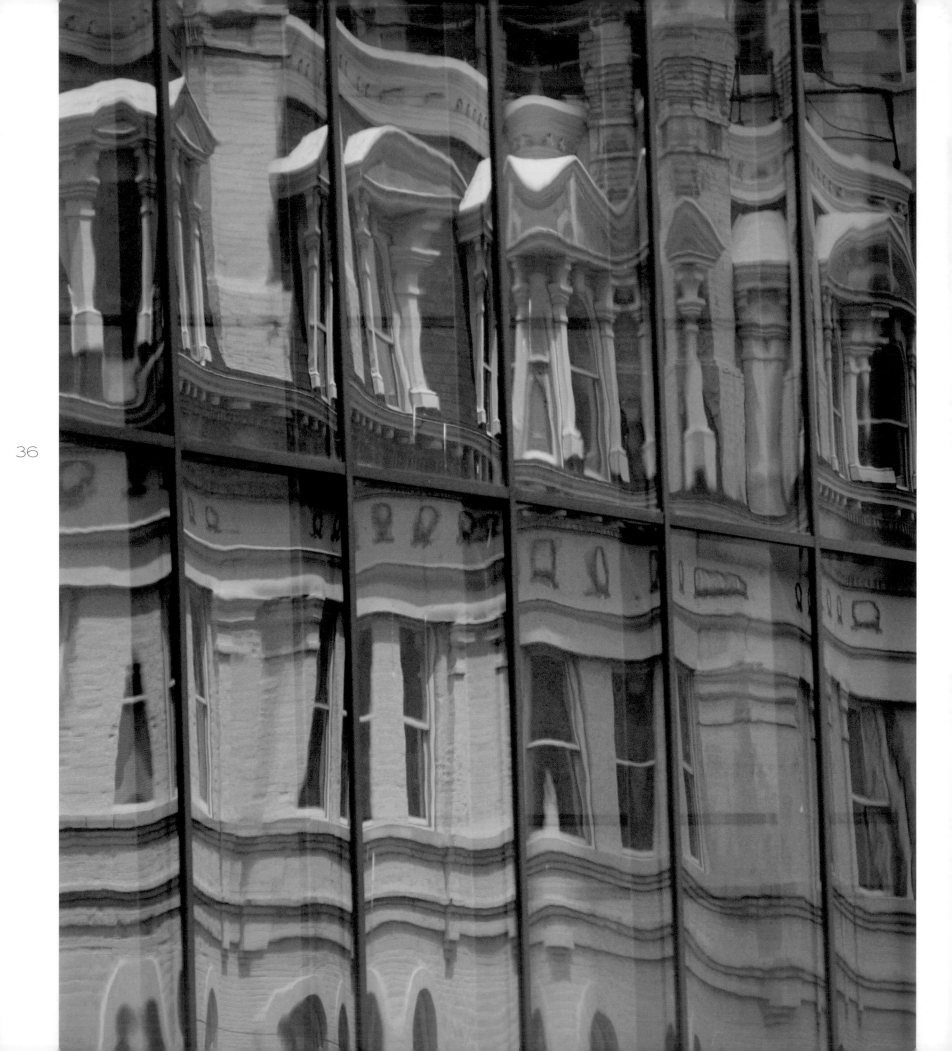

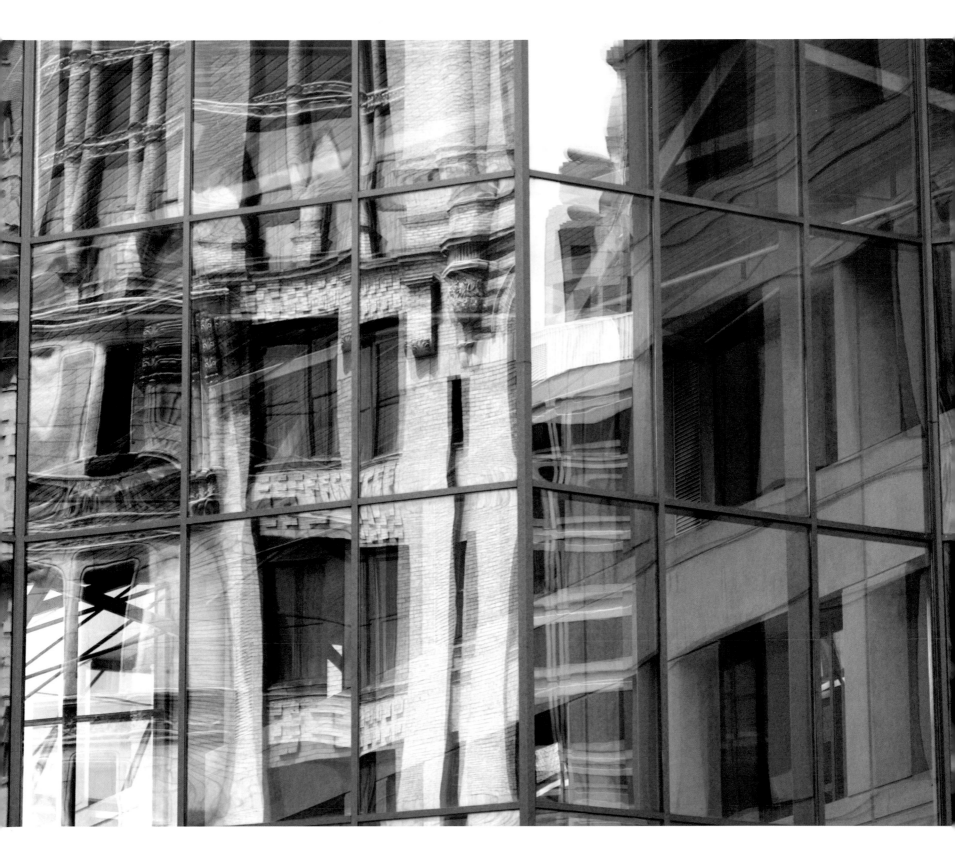

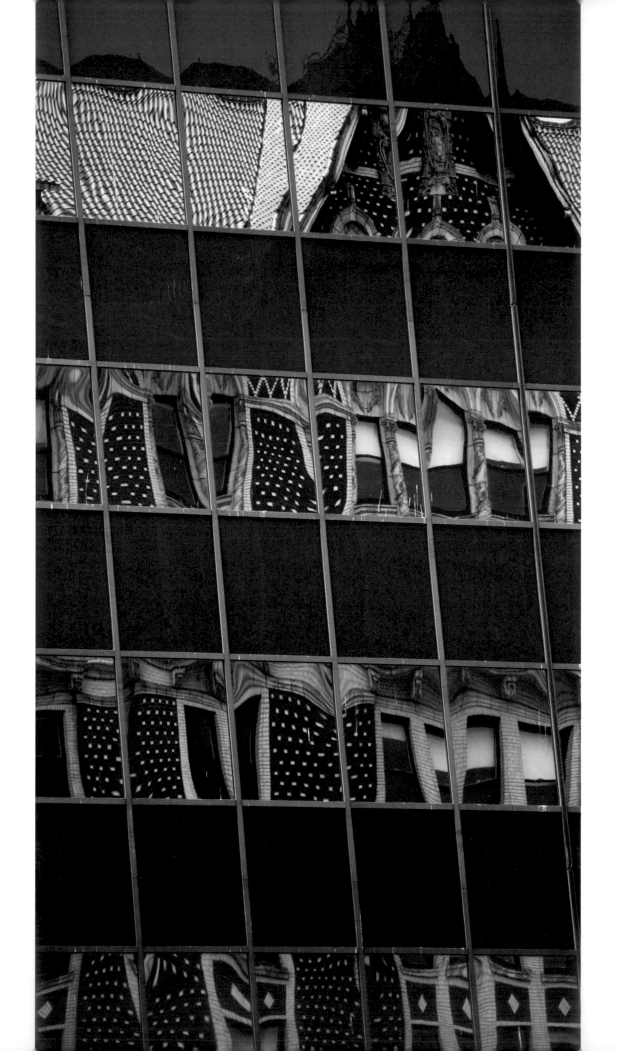

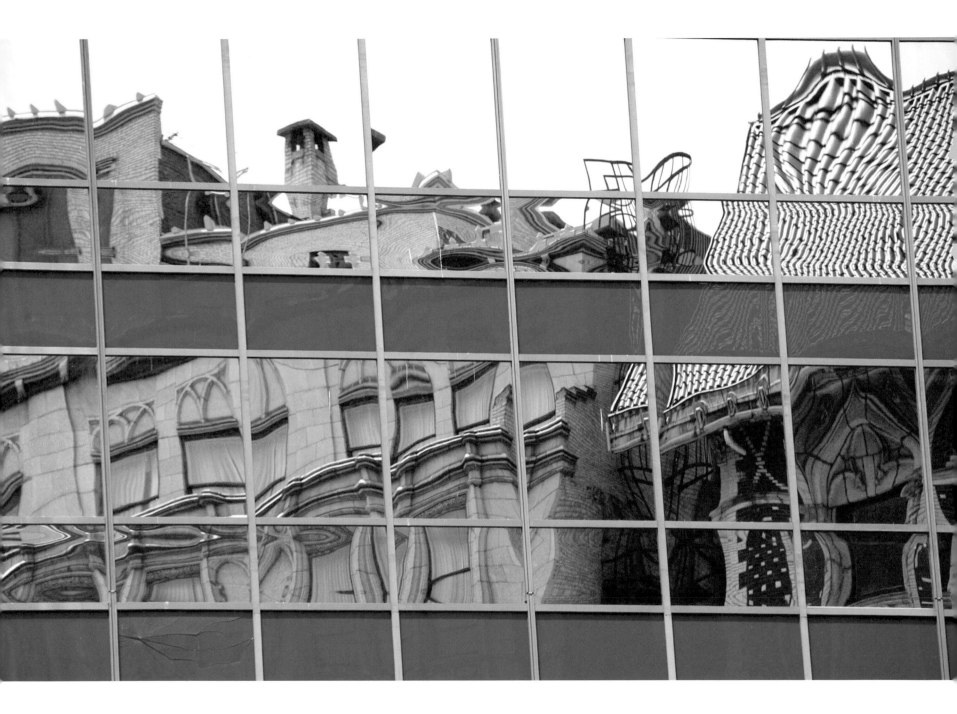

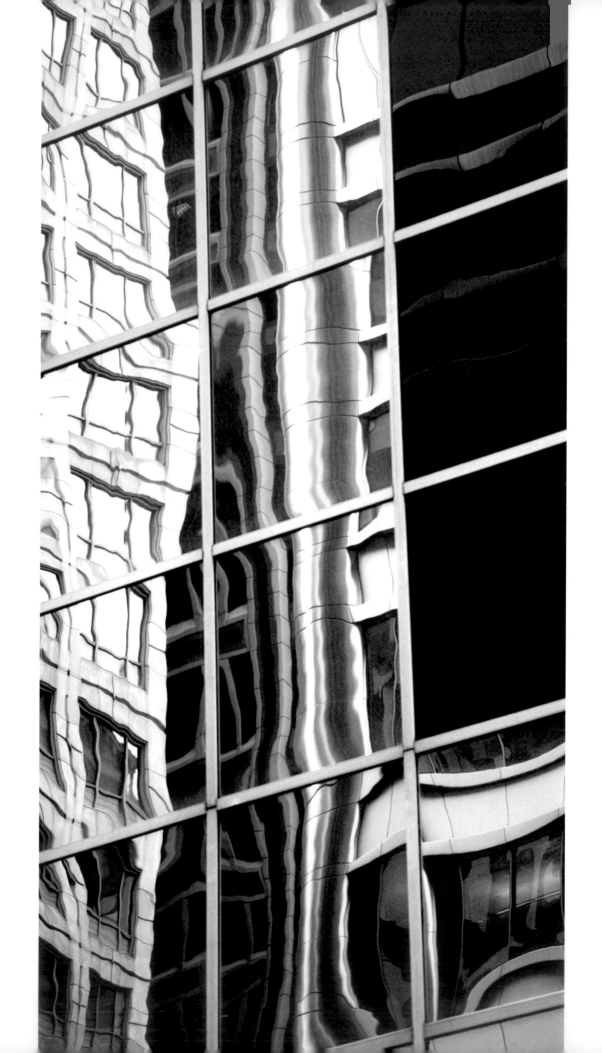

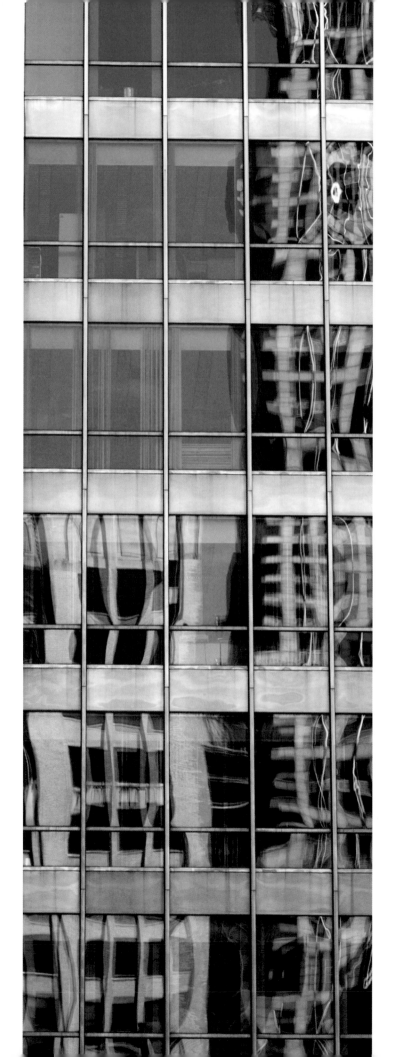
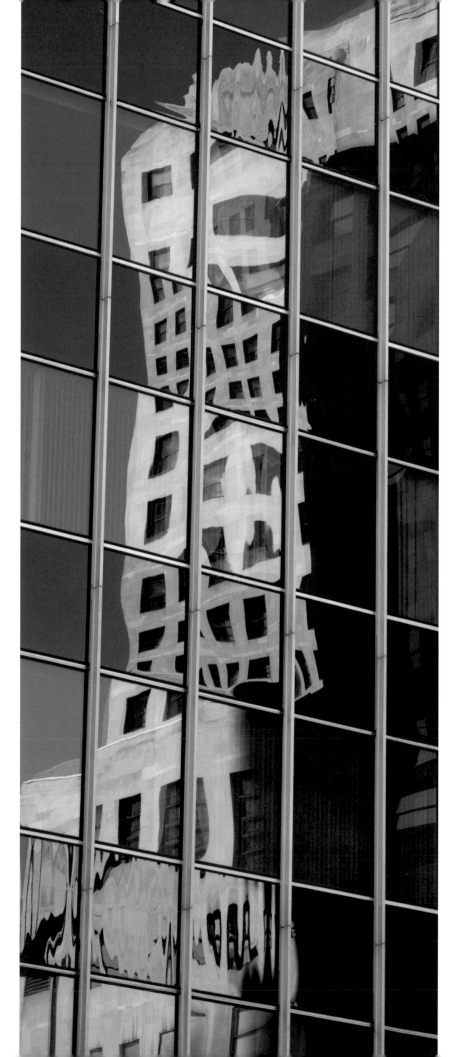

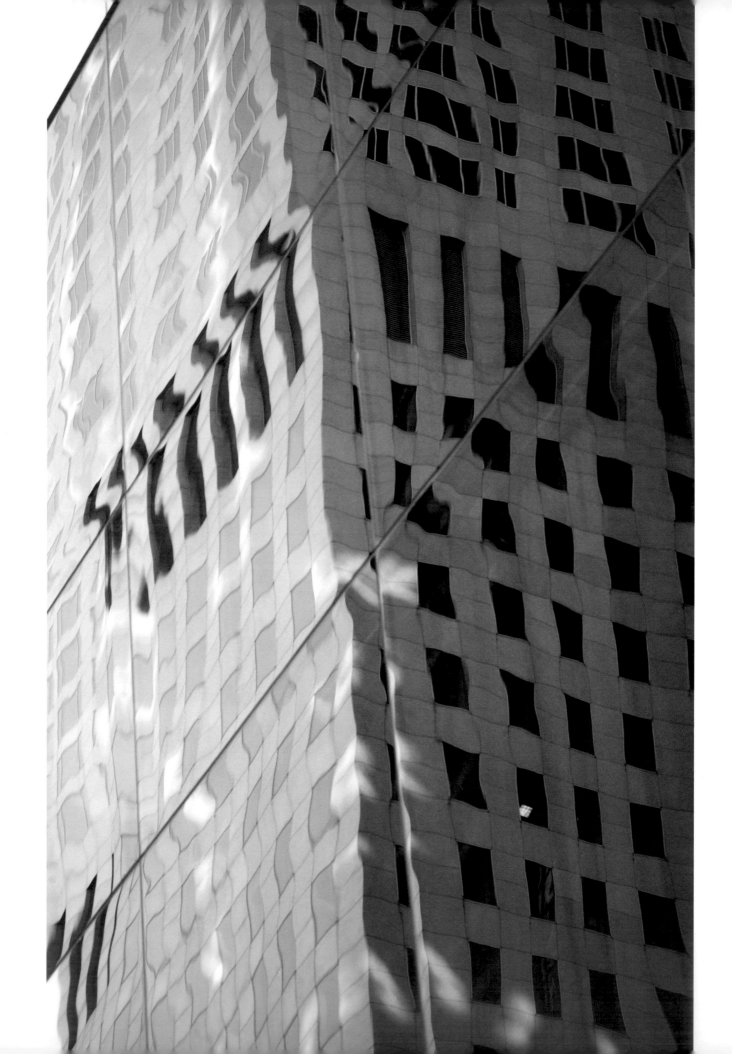

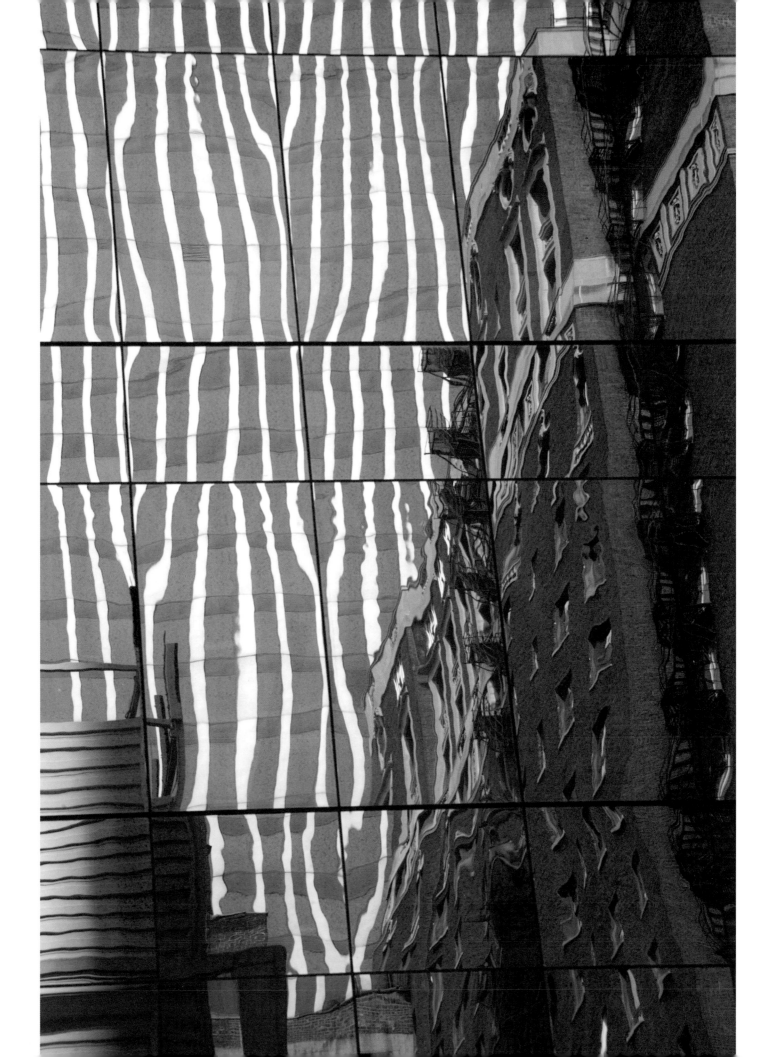

44

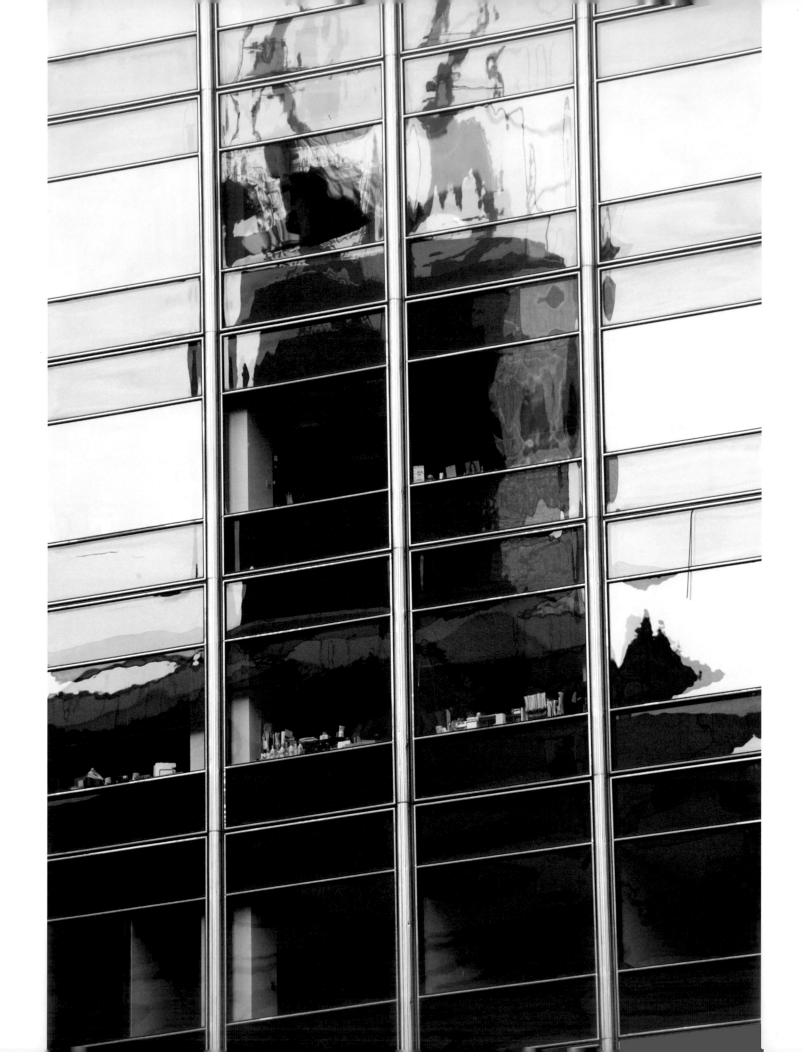

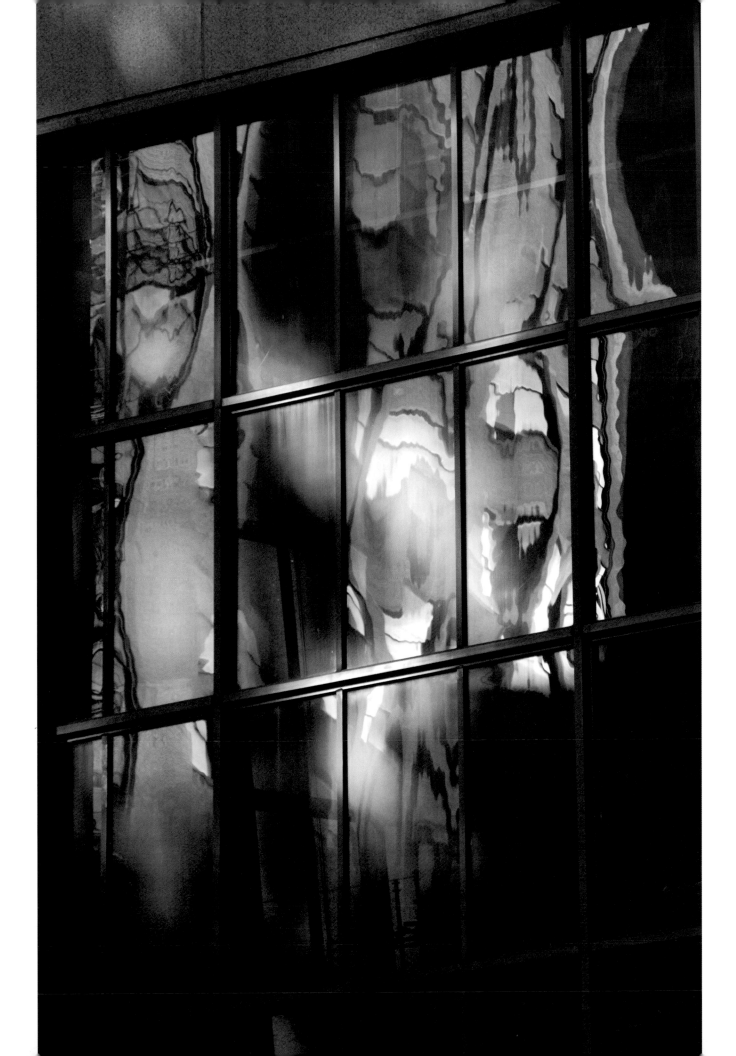

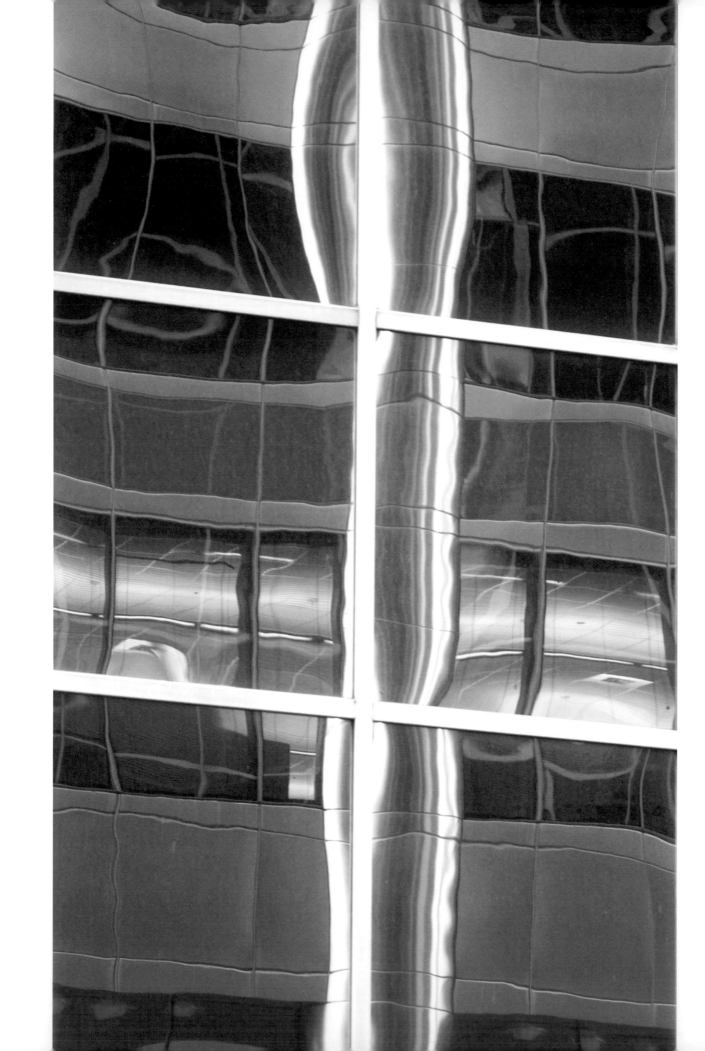

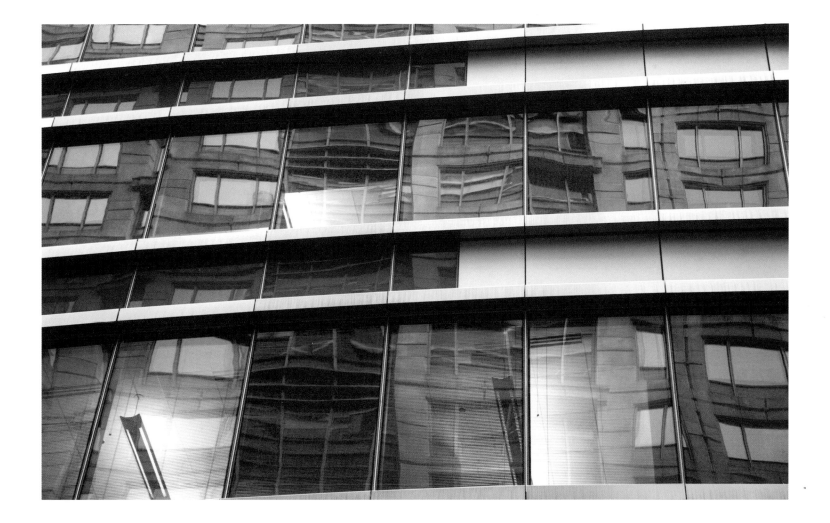

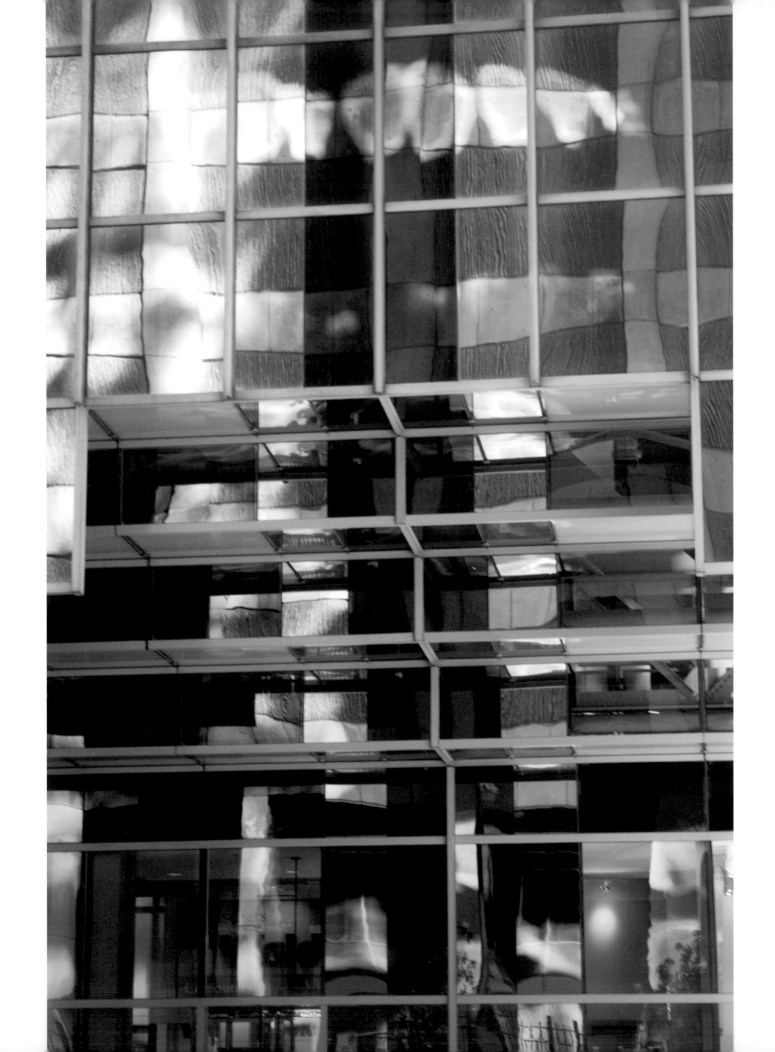

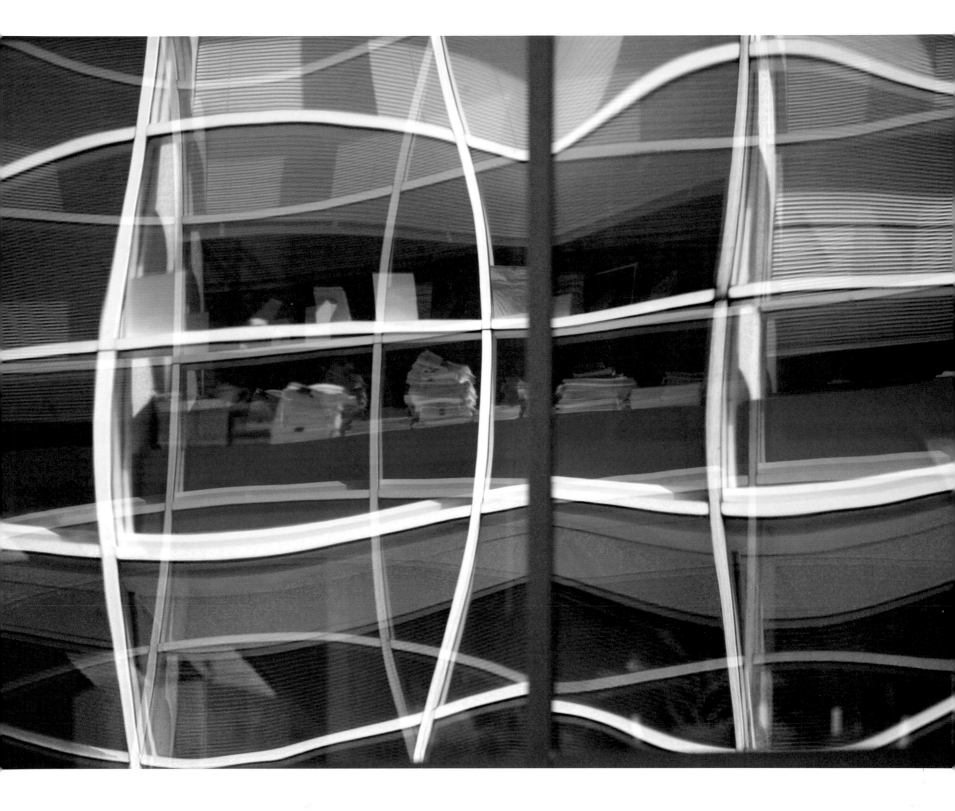

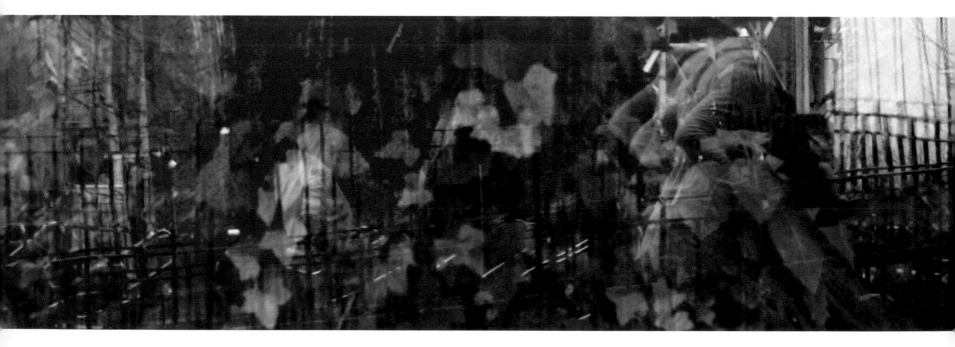

2
Reflections on the City

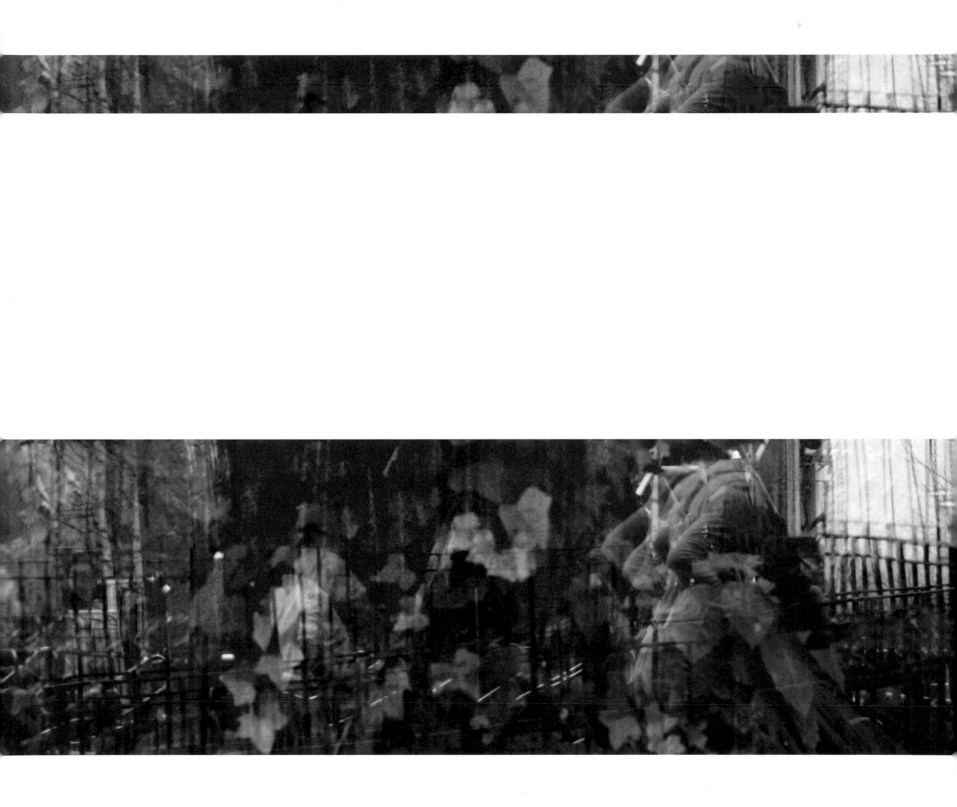

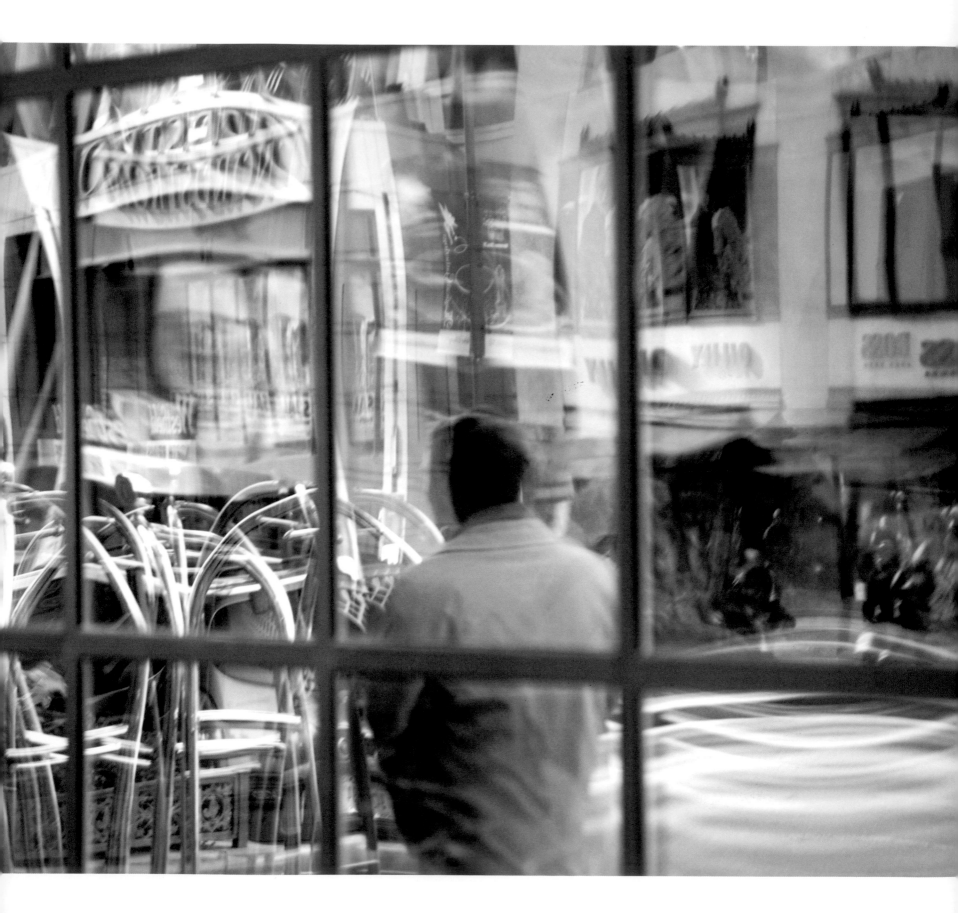

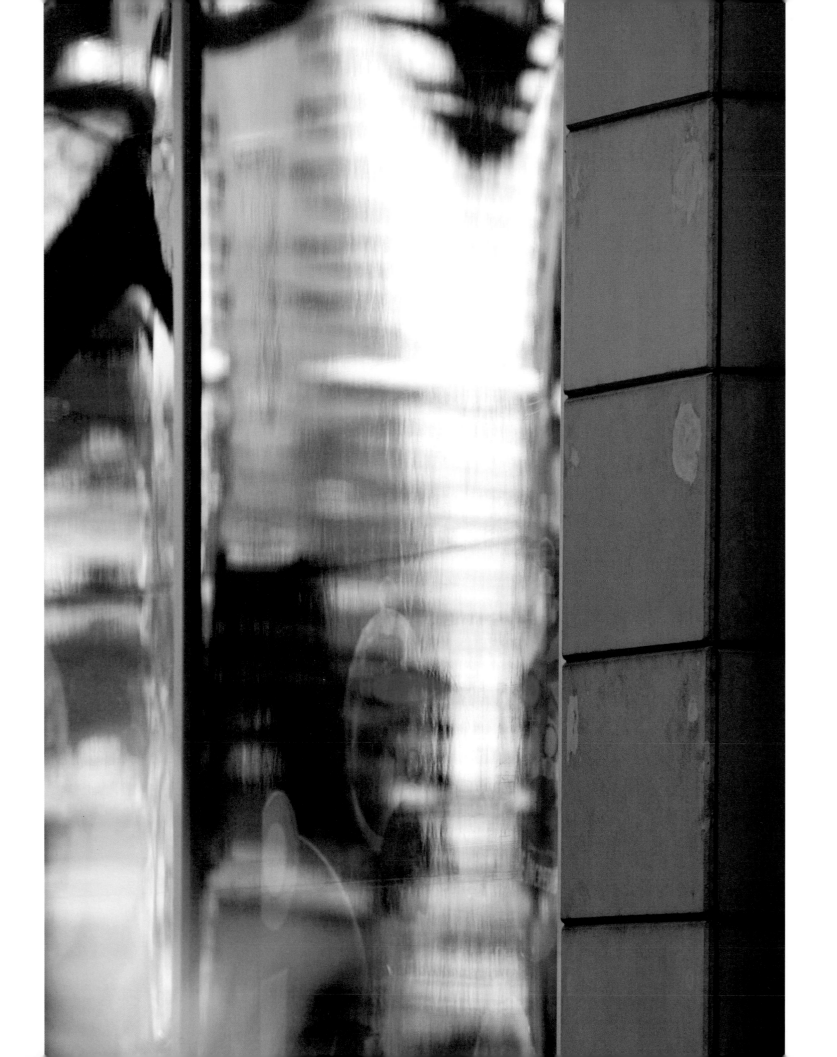

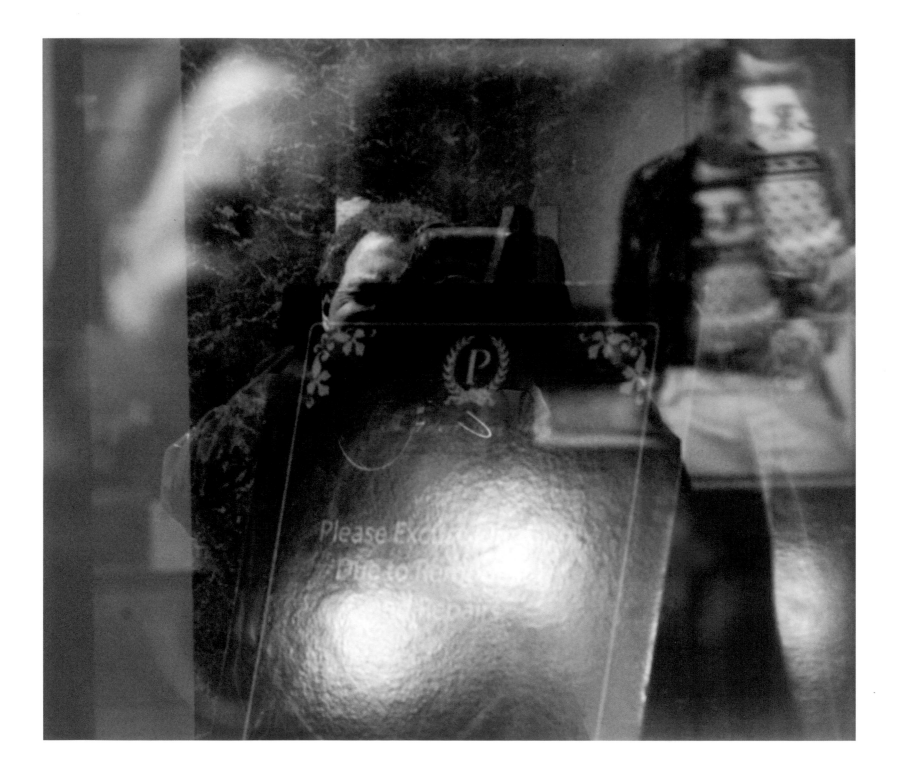

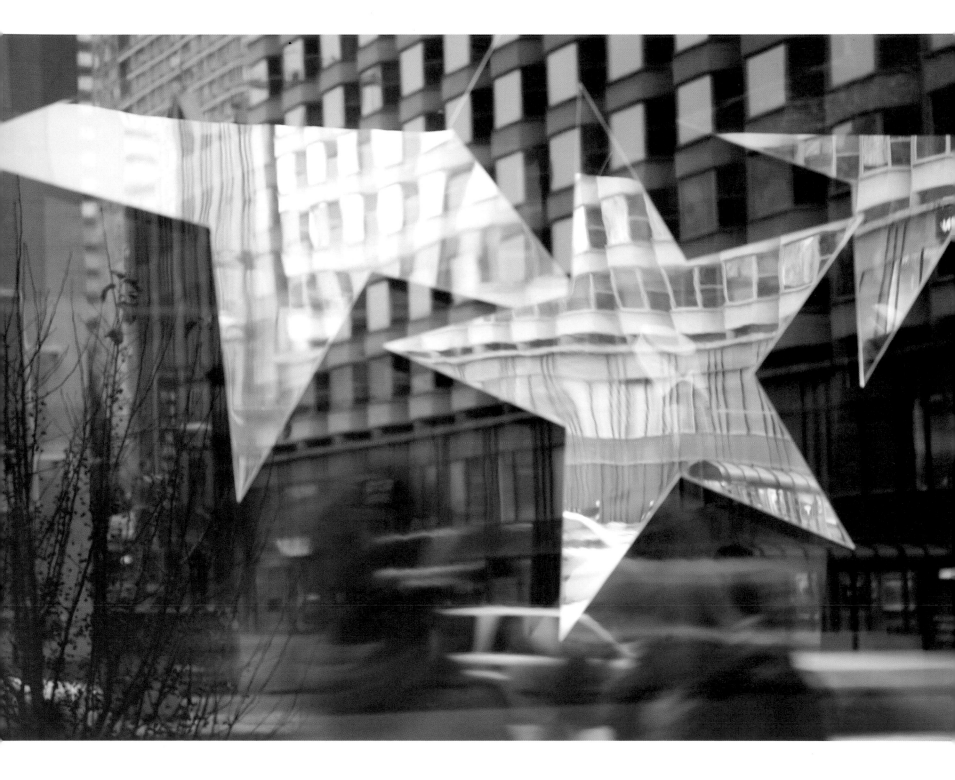

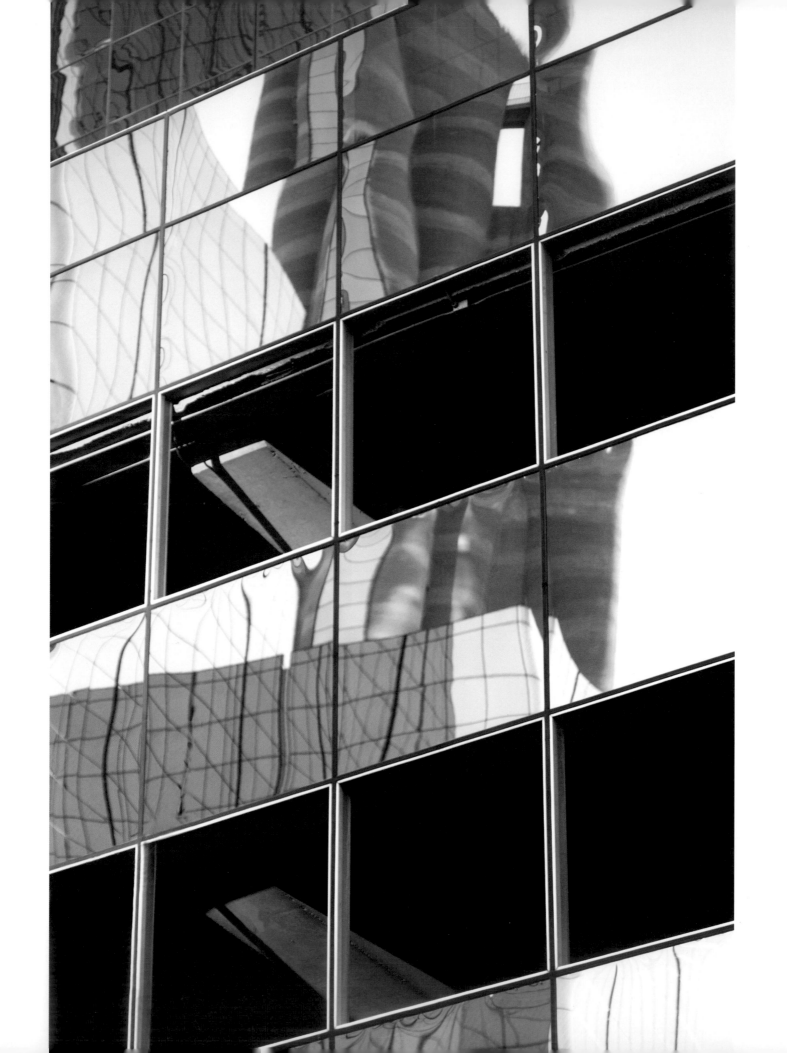

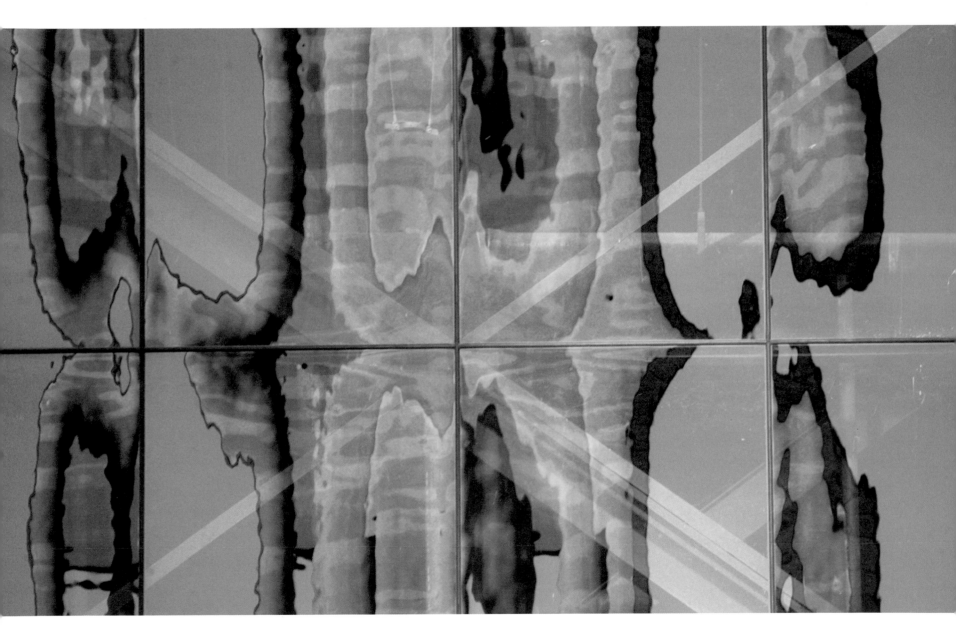

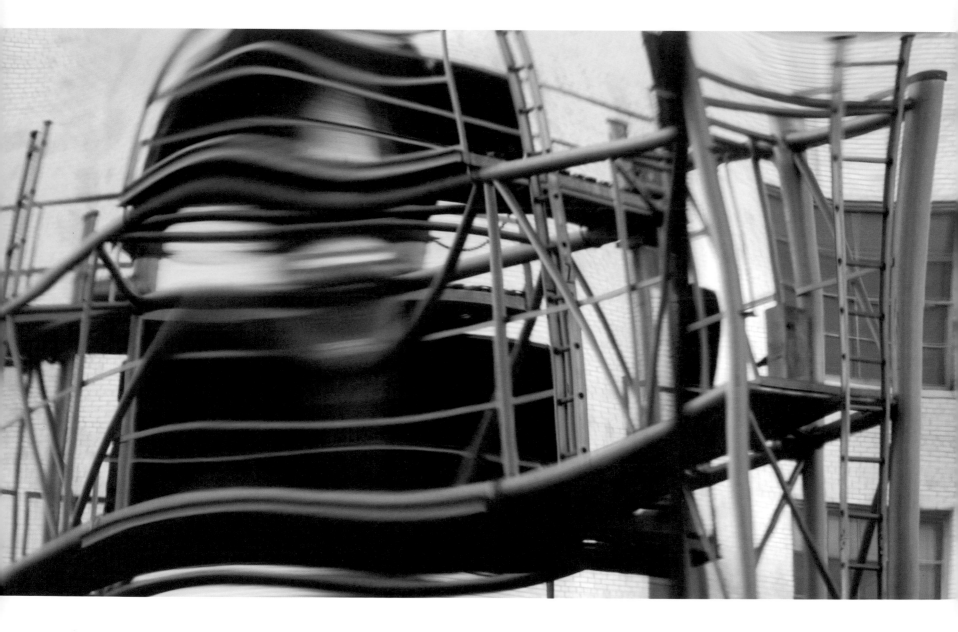

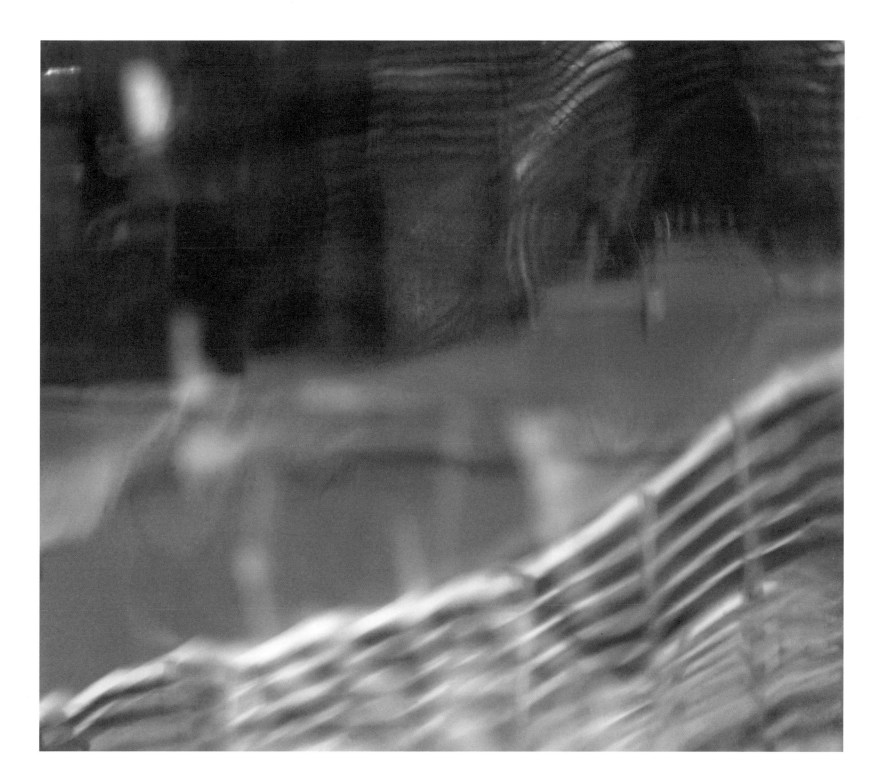

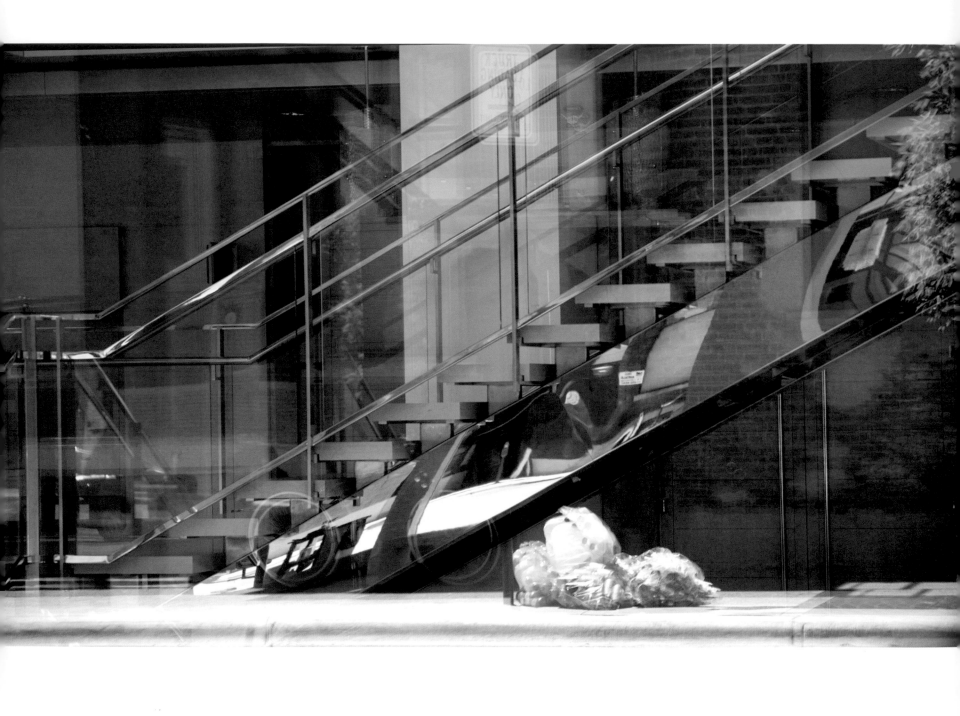

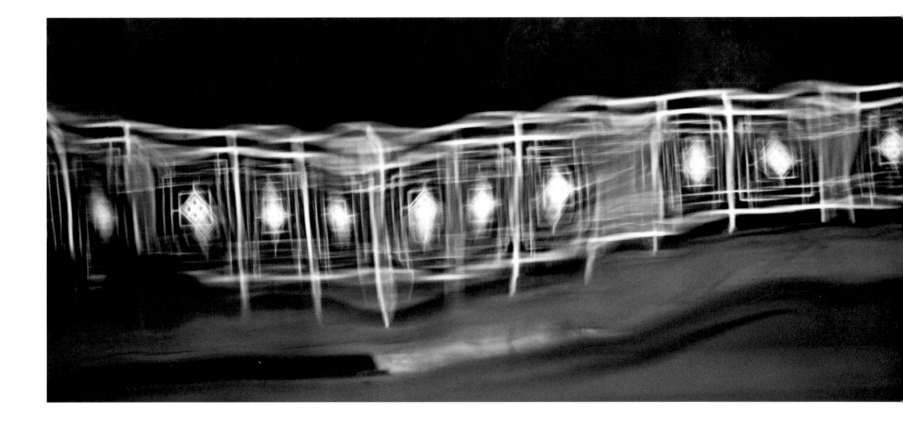

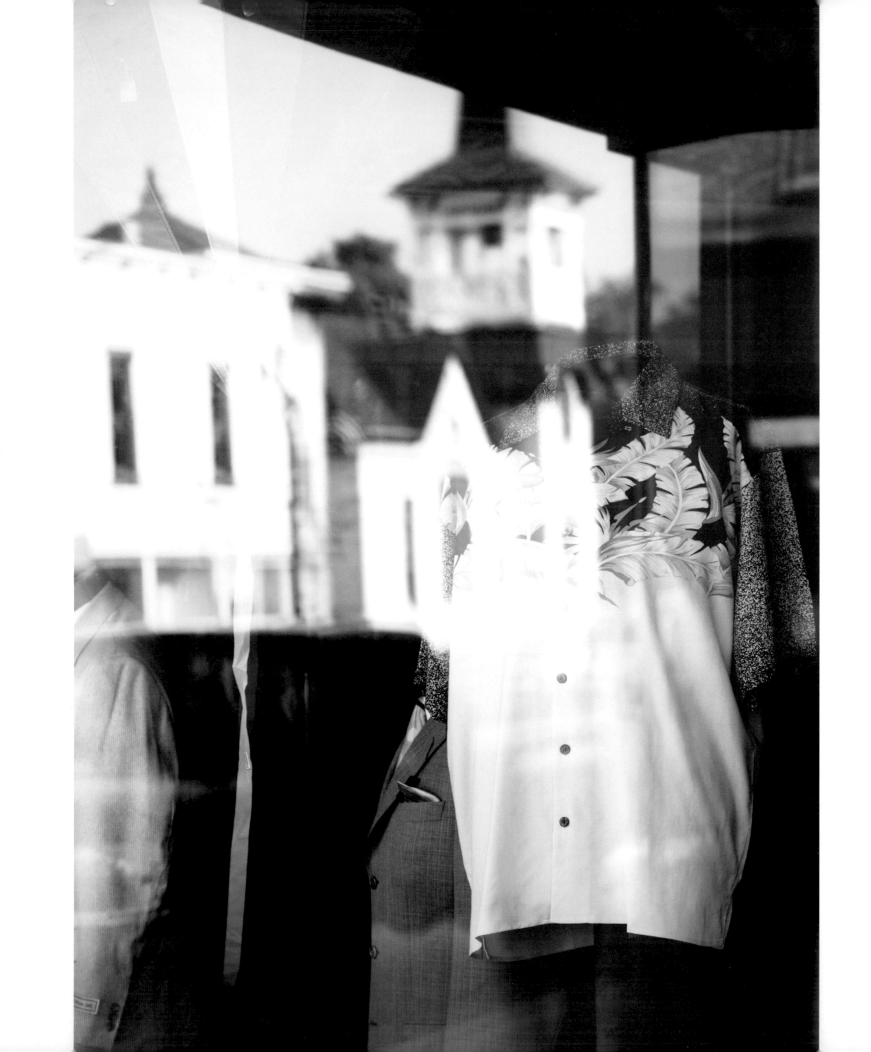

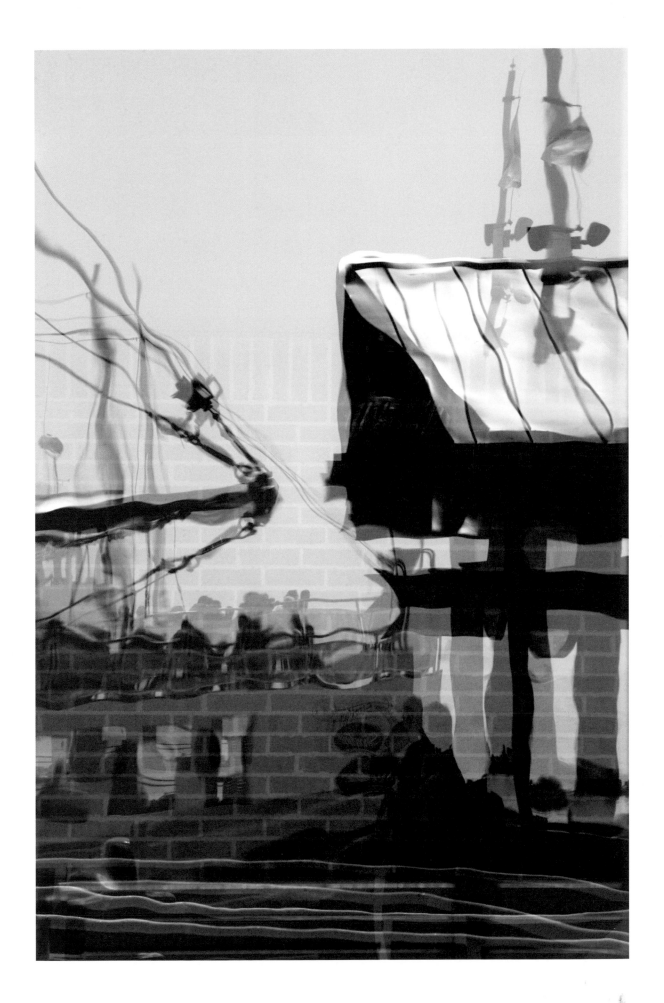

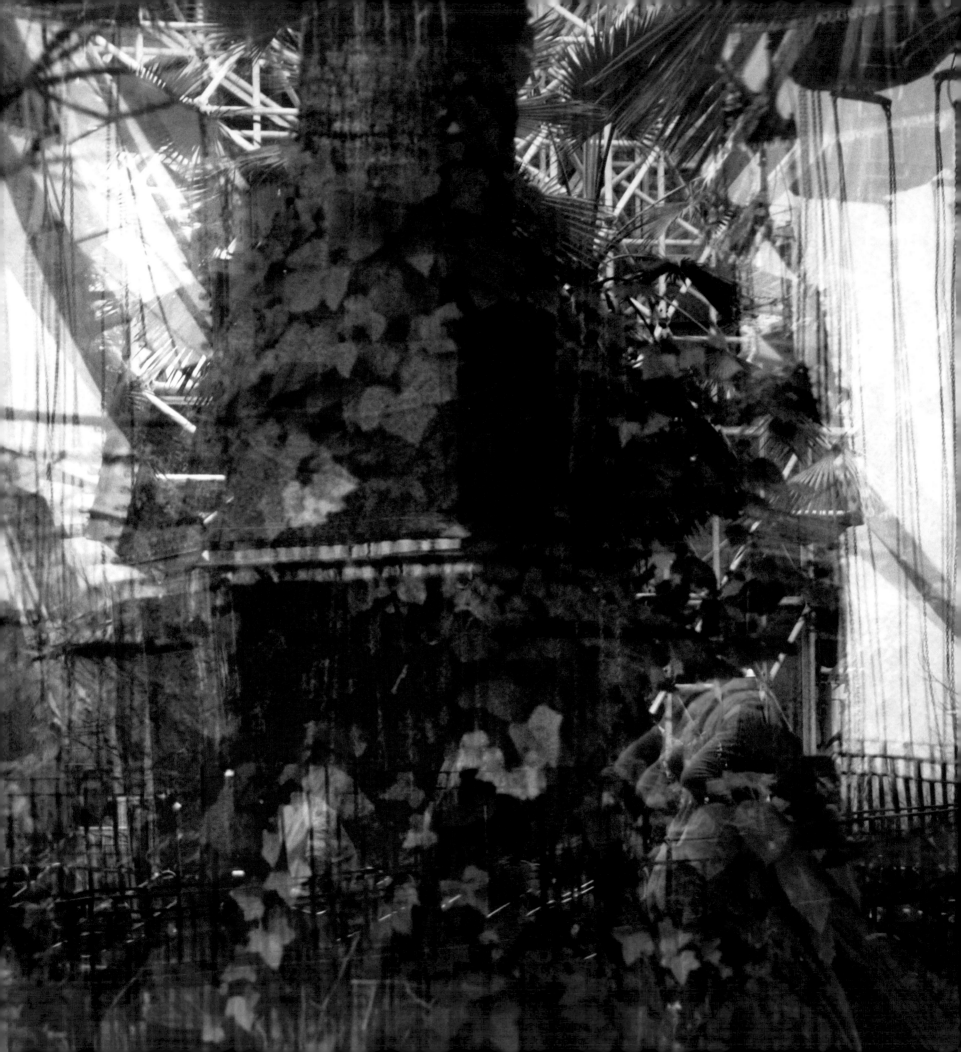

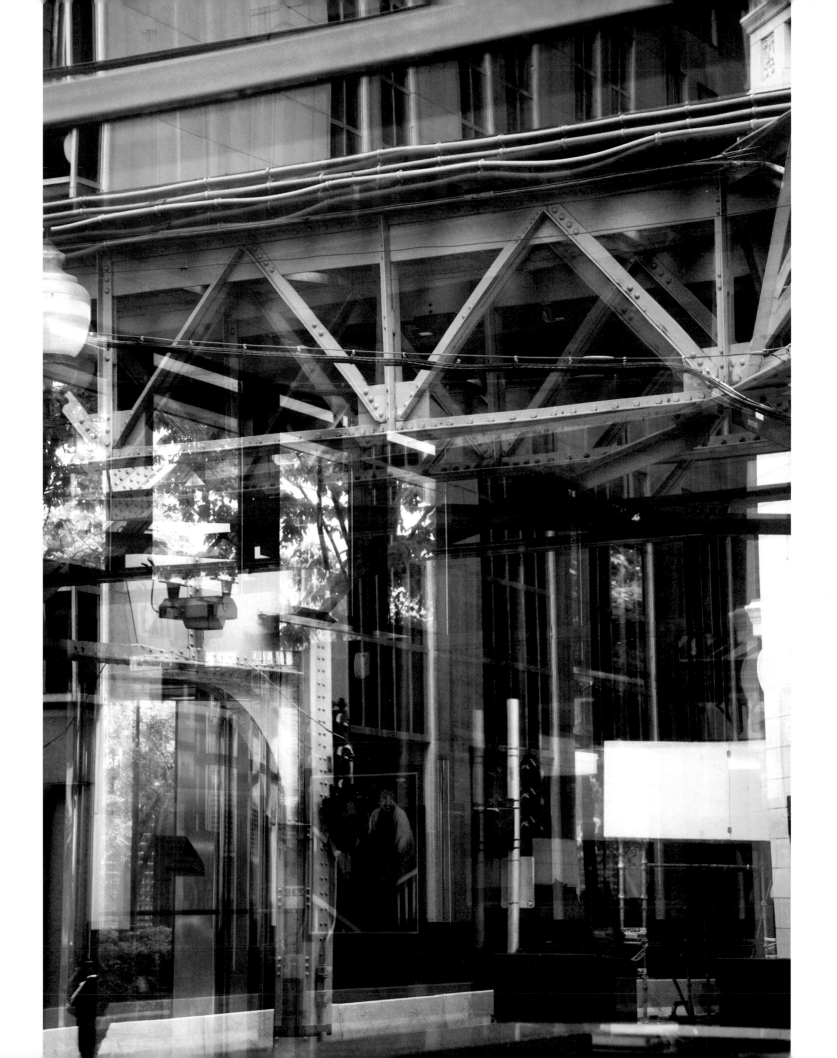

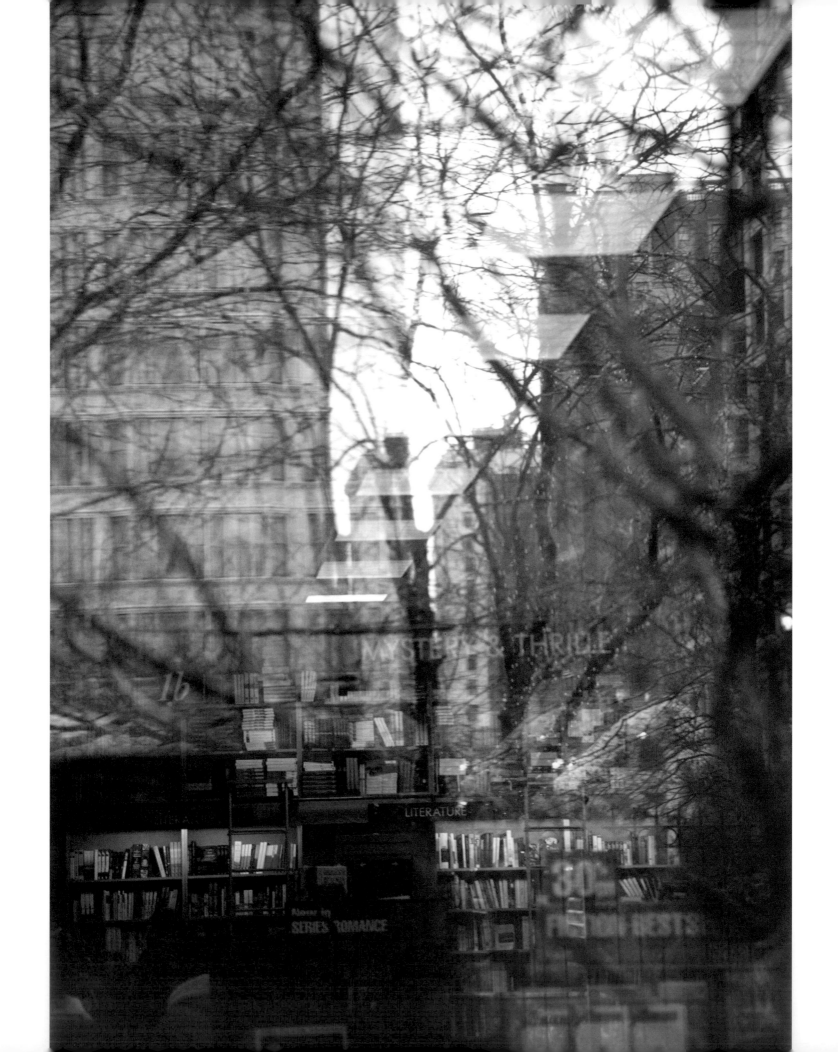

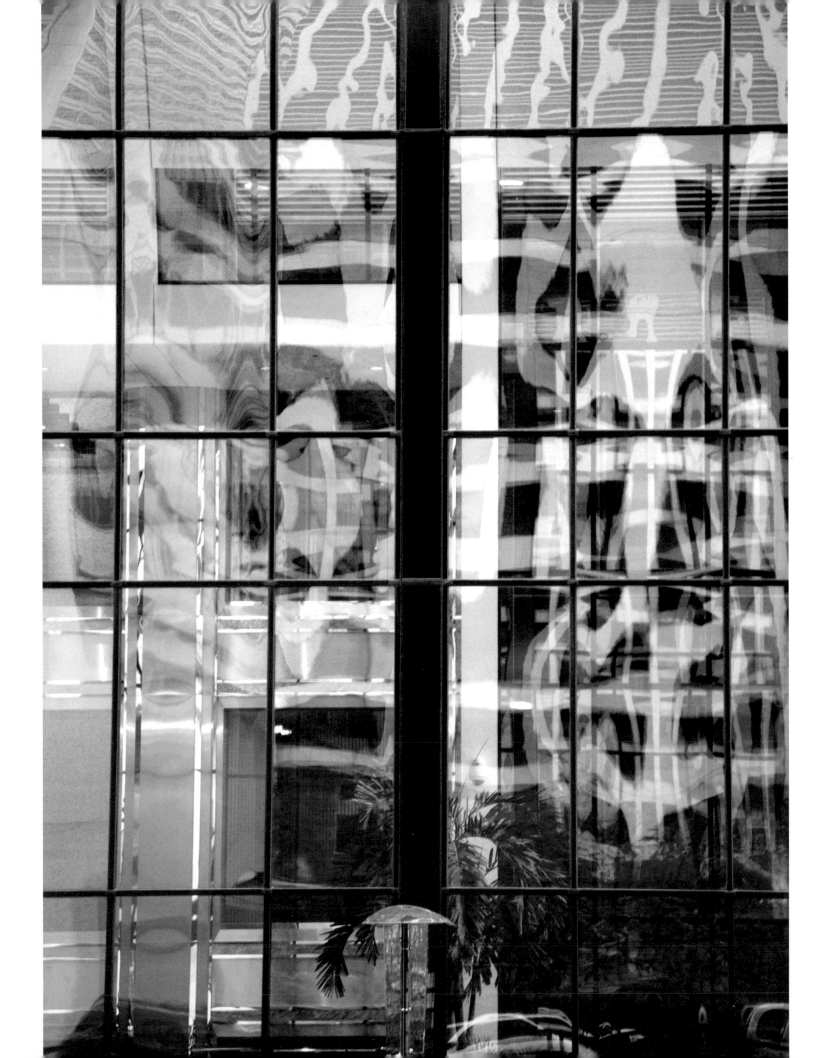

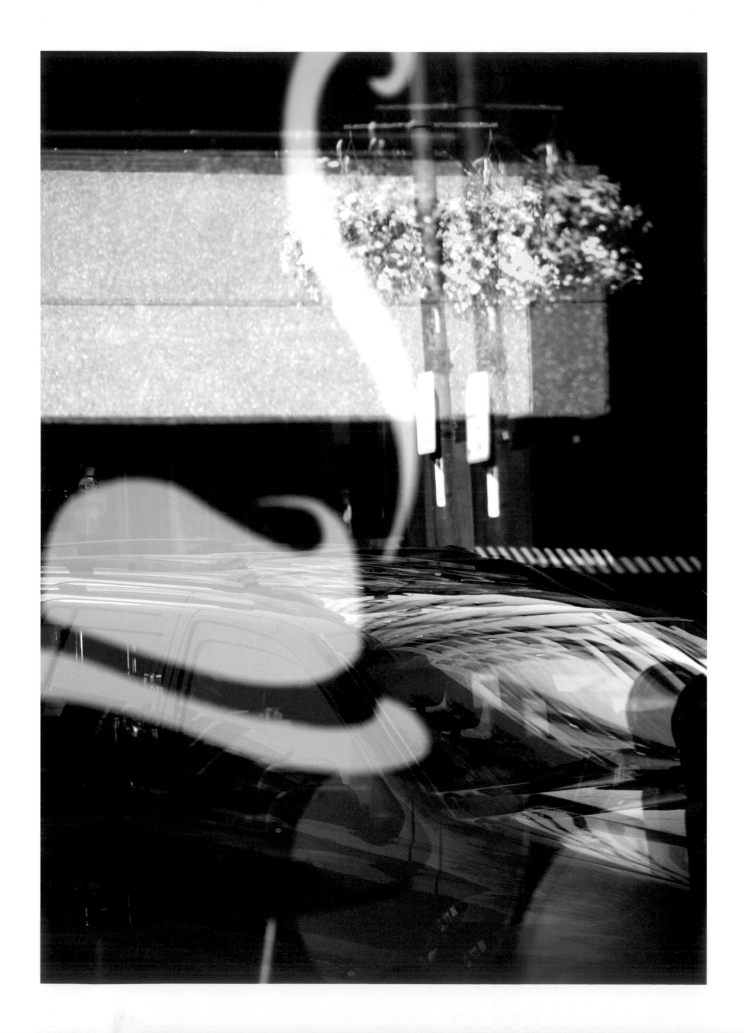

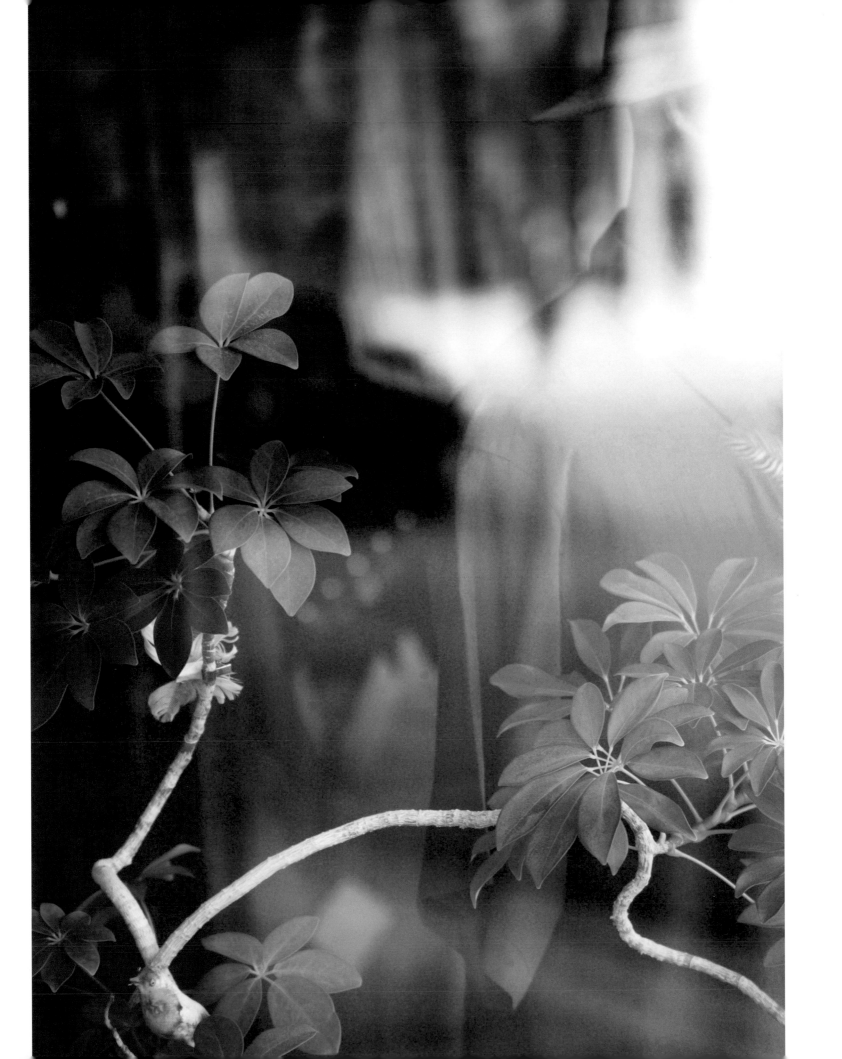

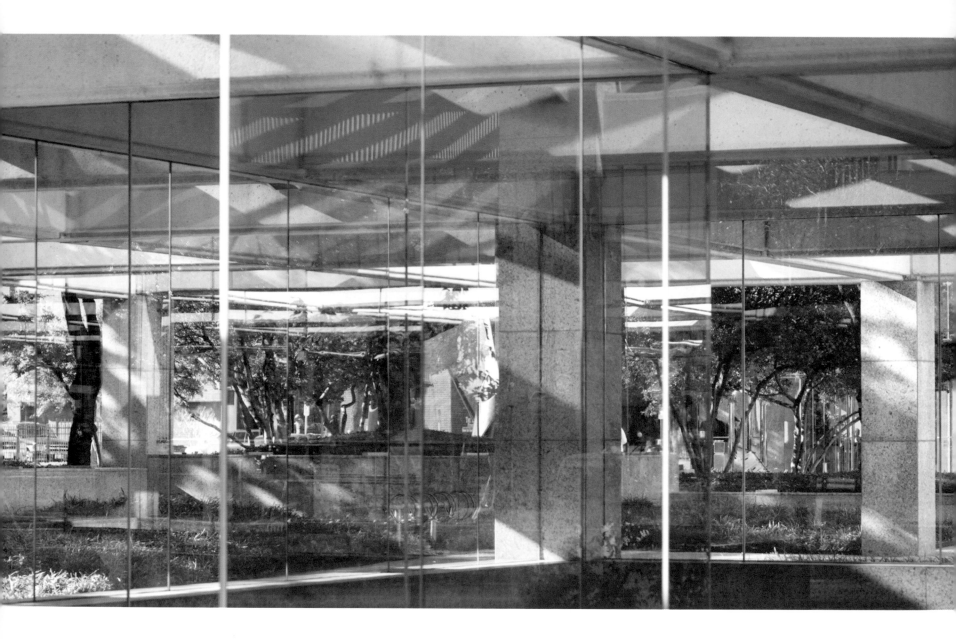

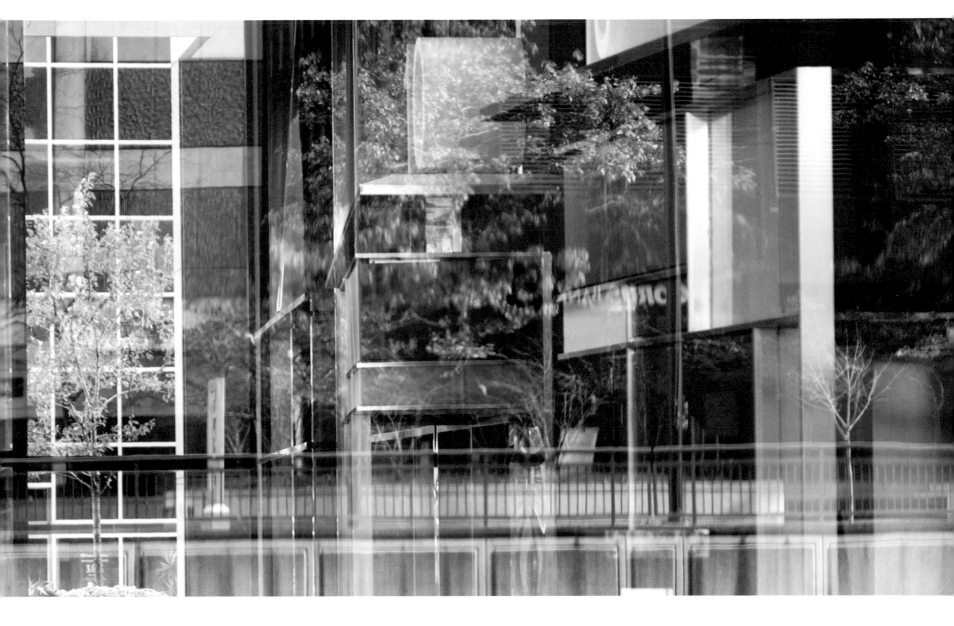

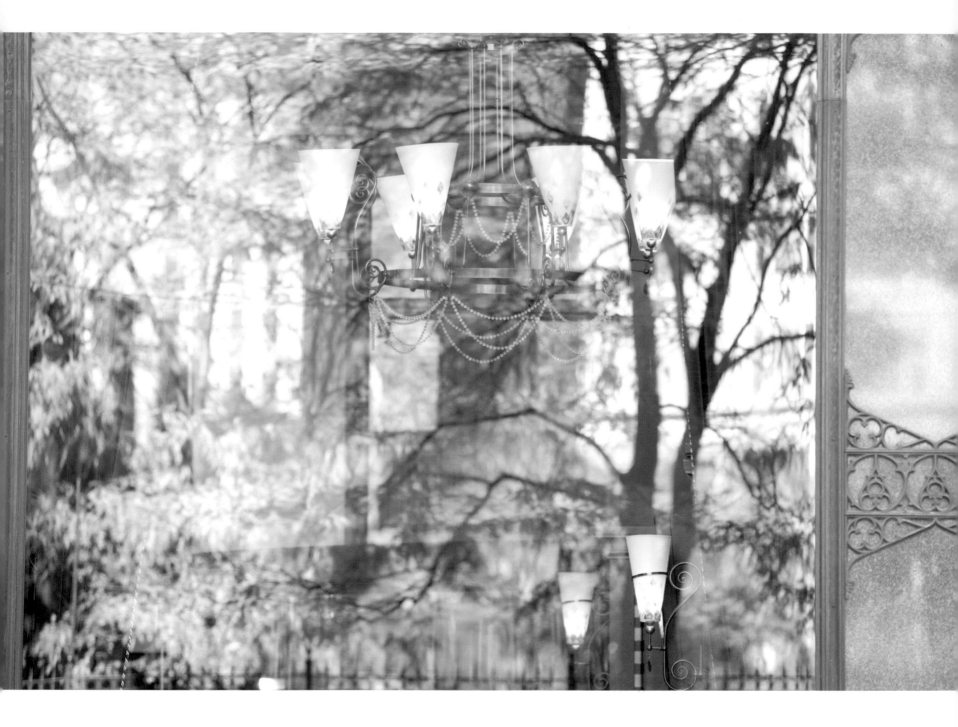

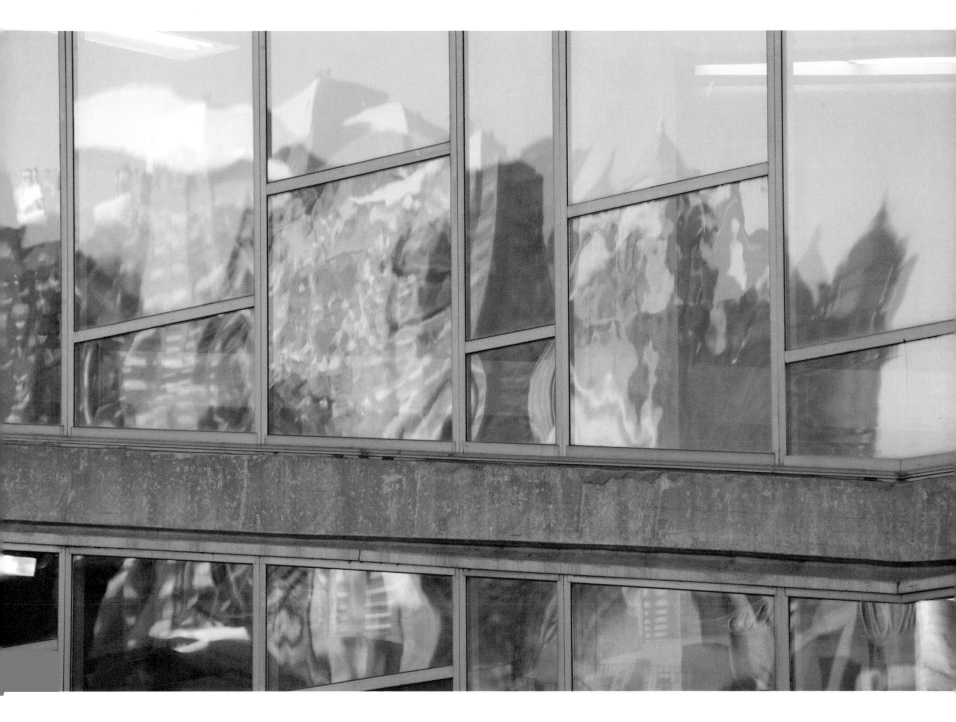

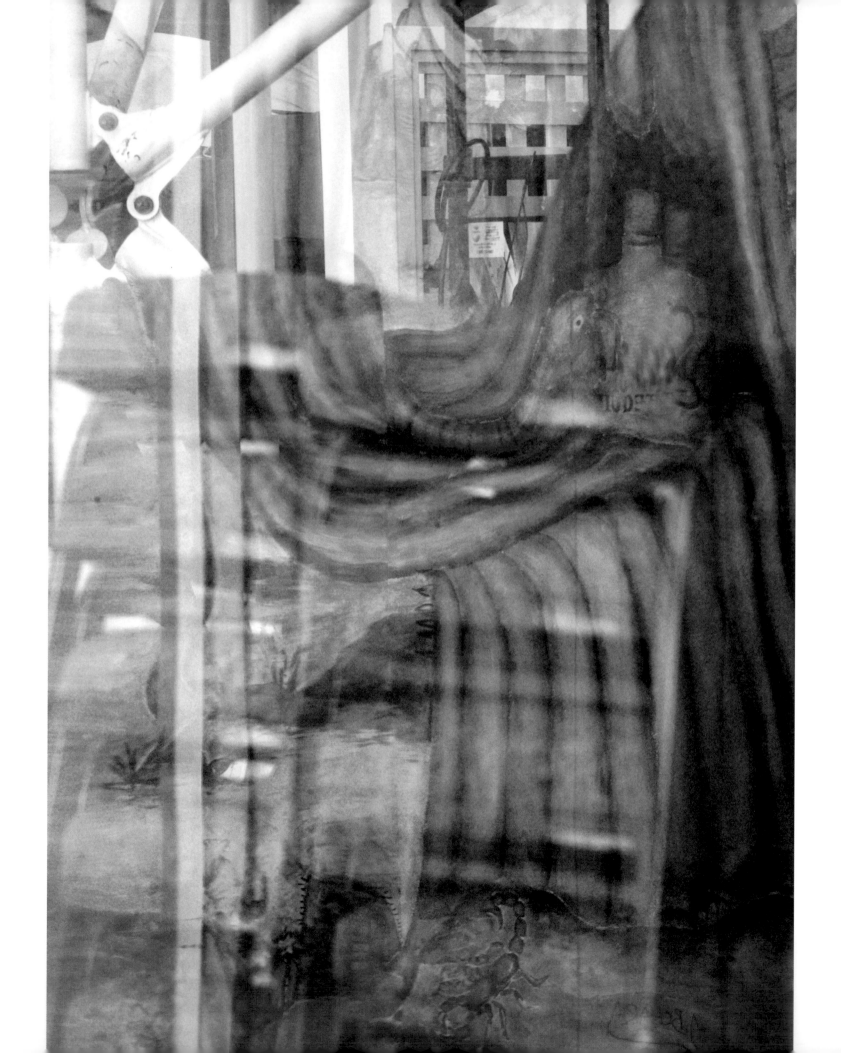

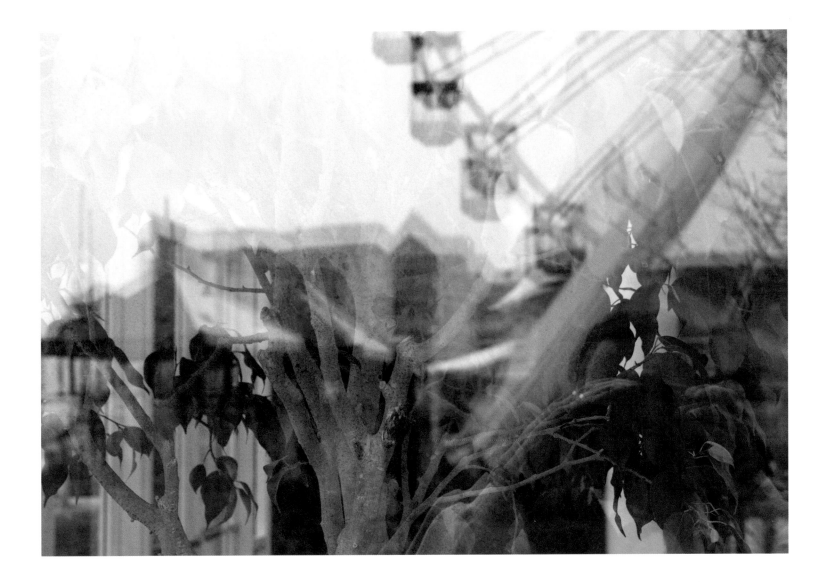

3
Window Galleries

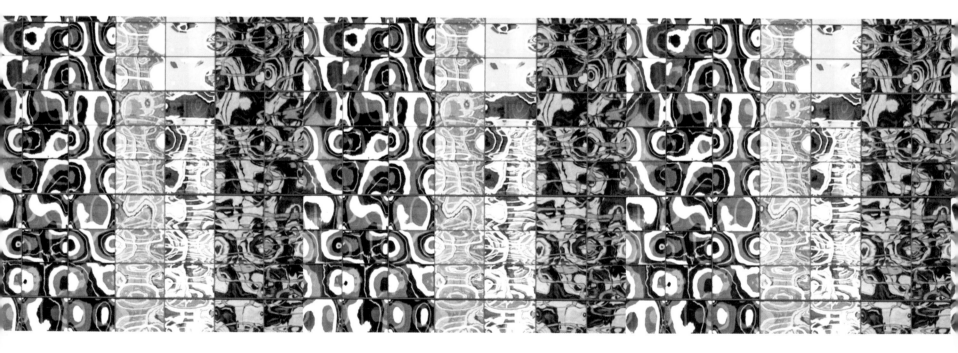

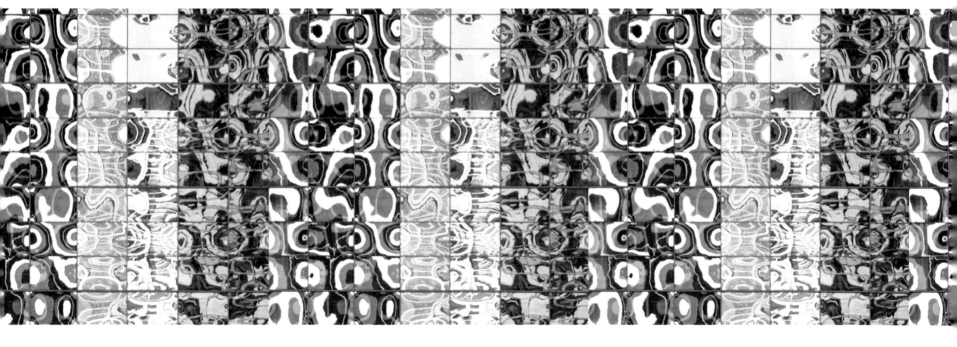

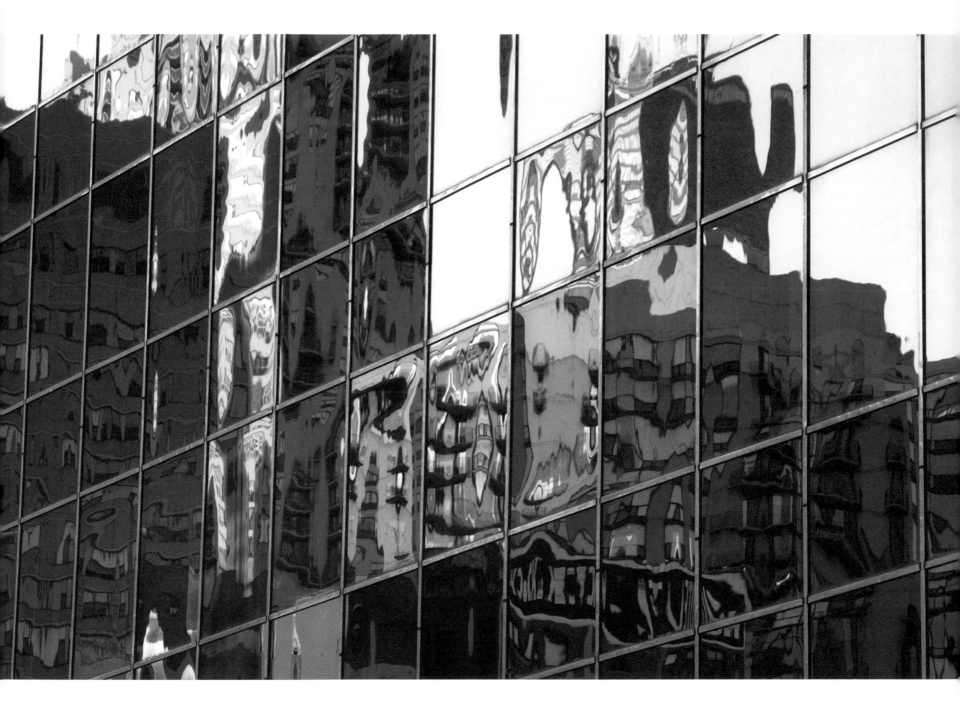

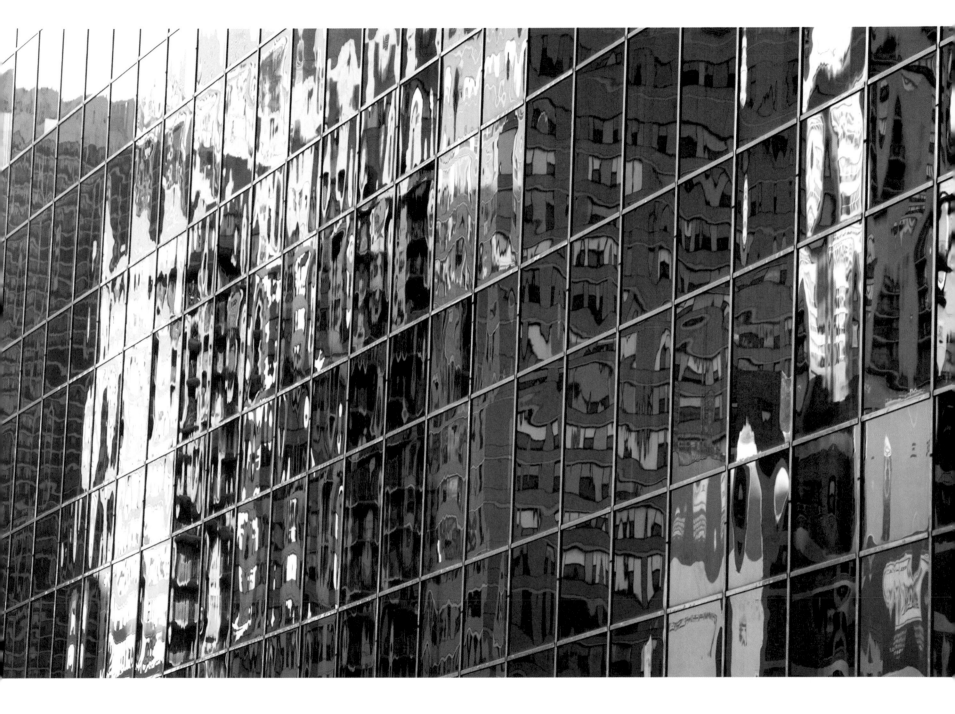

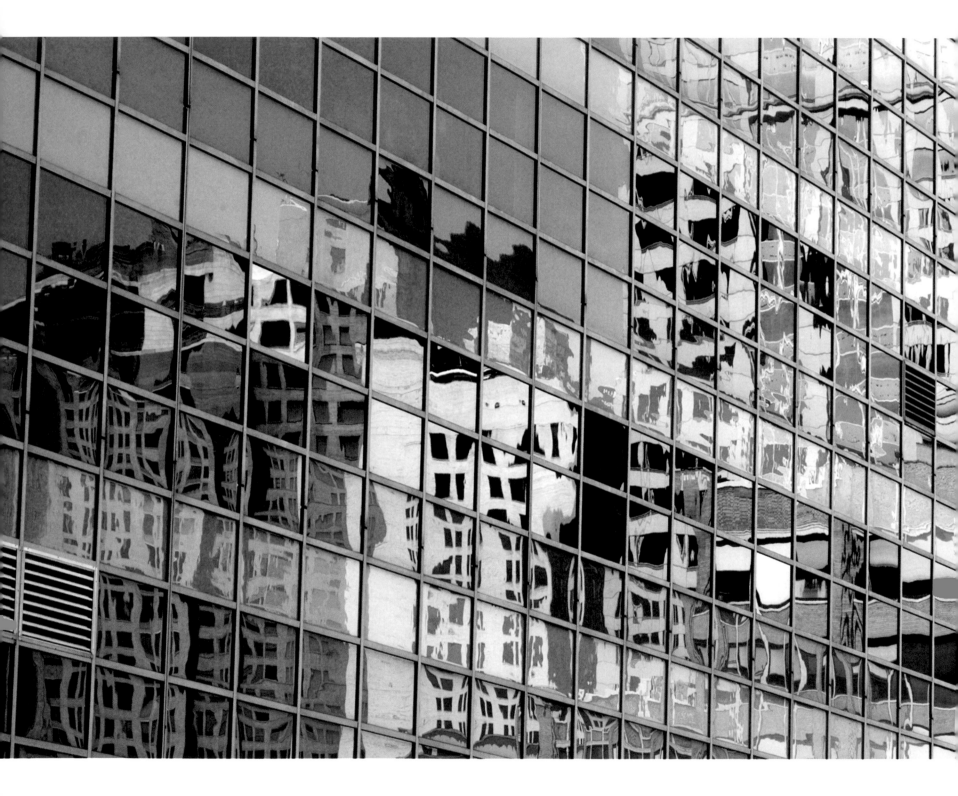

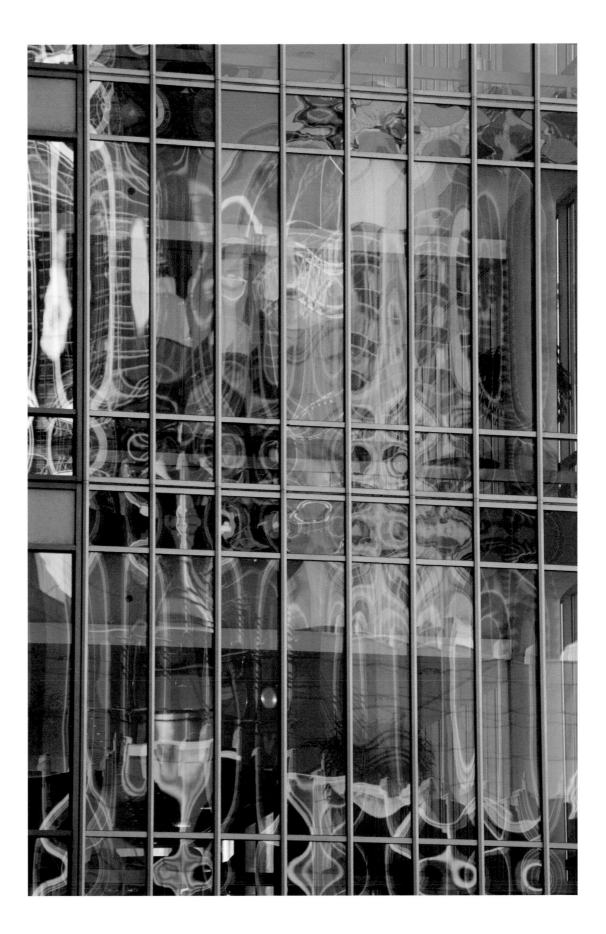

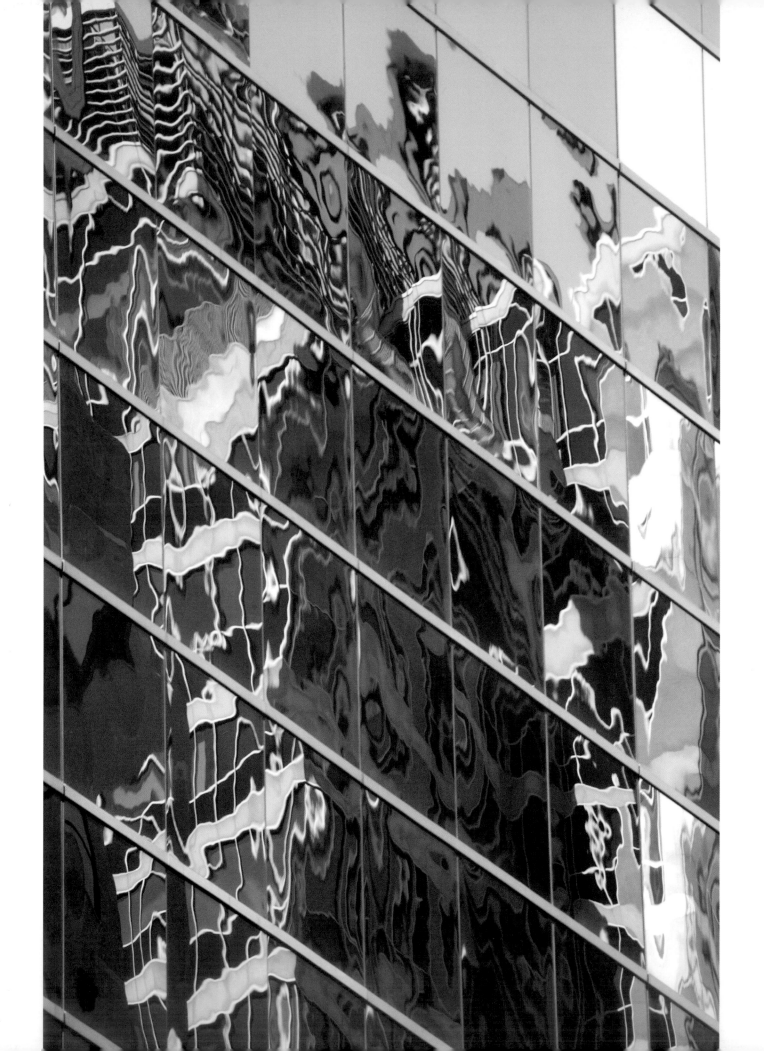

82

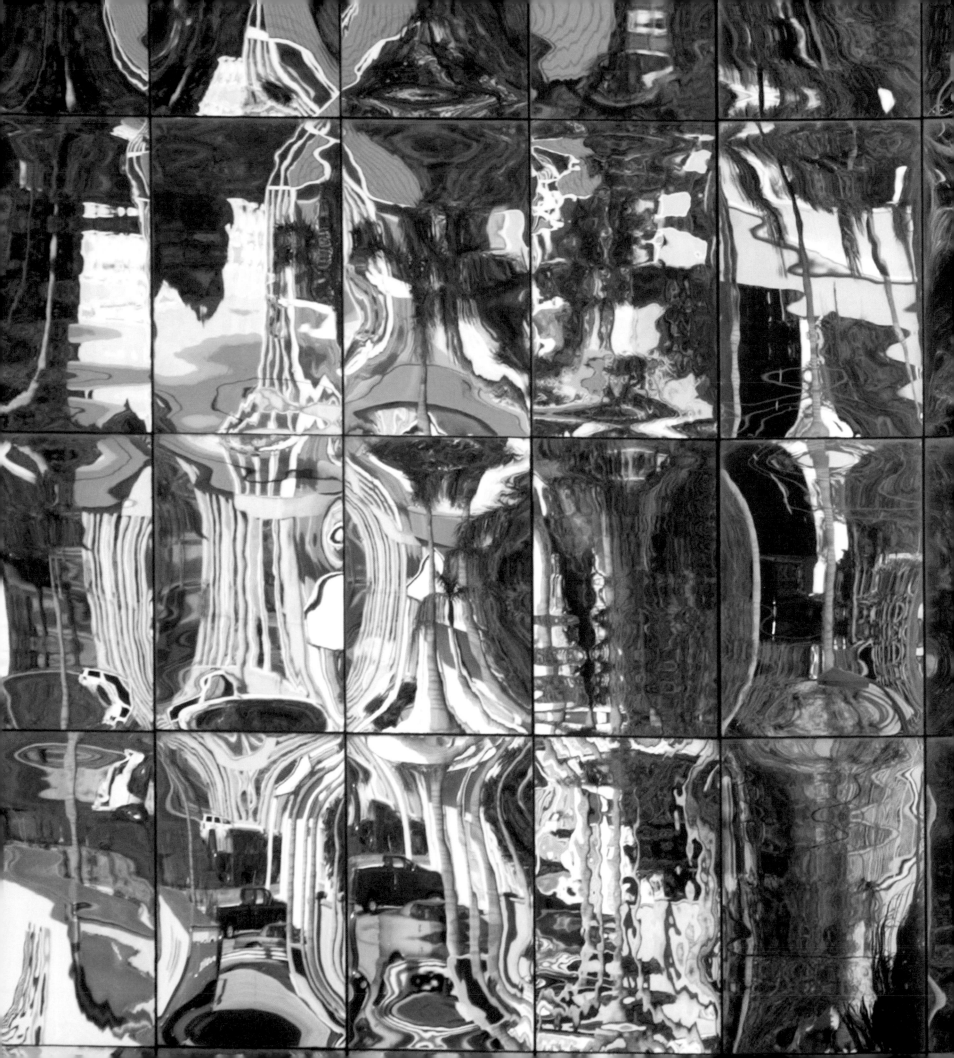

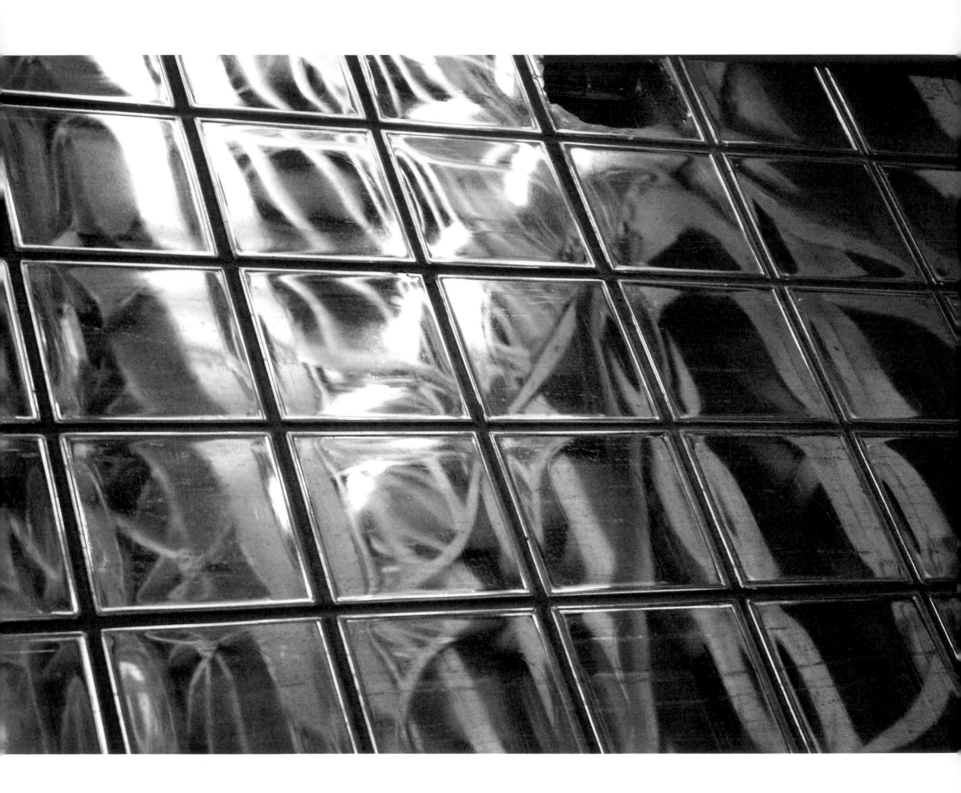

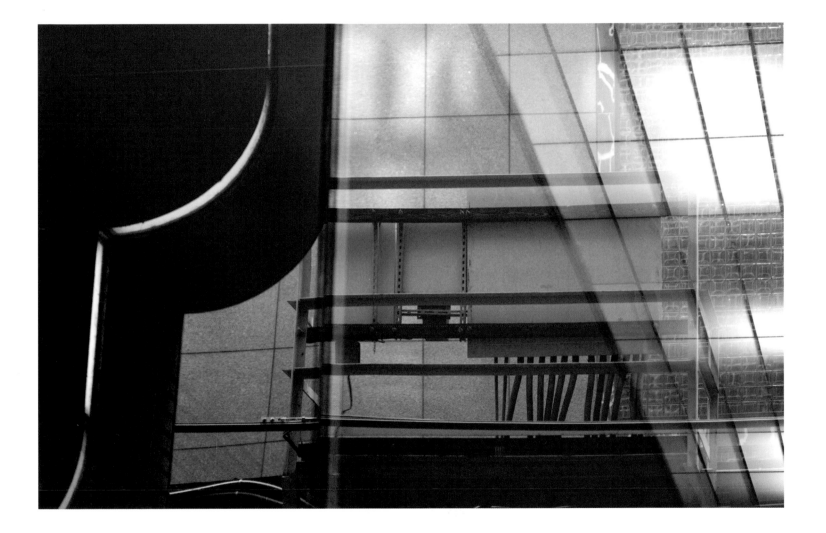

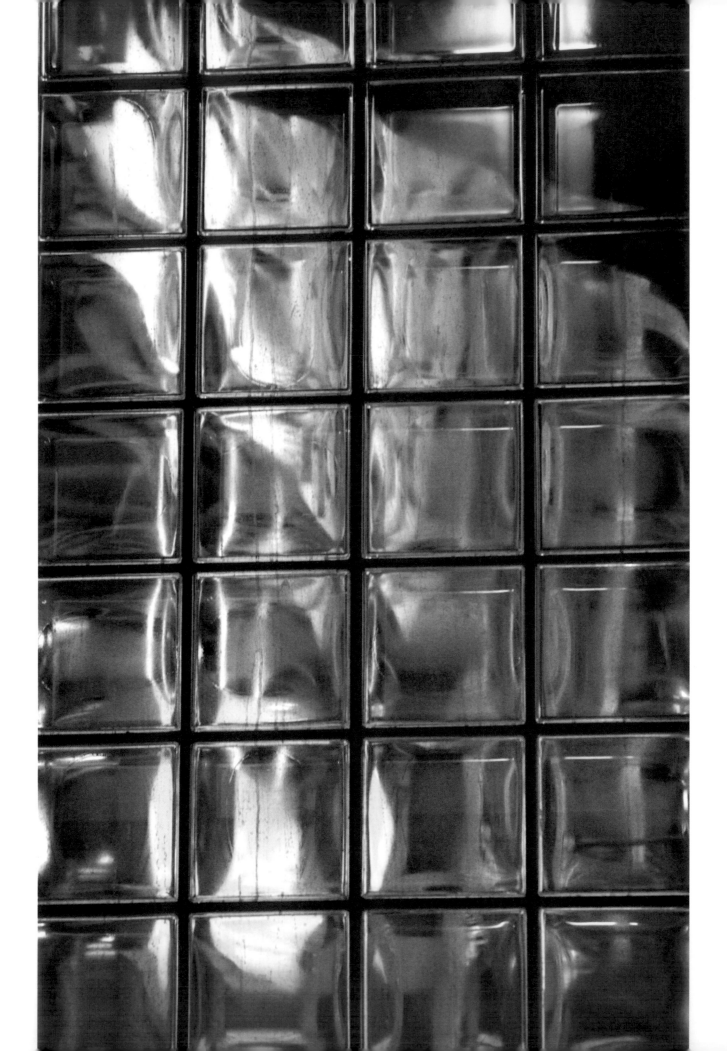

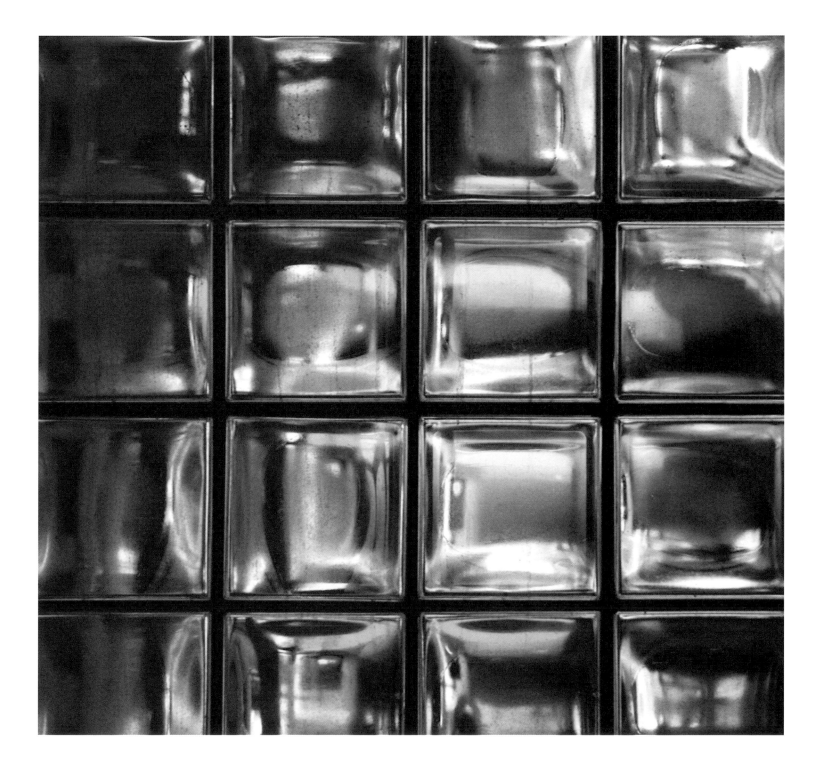

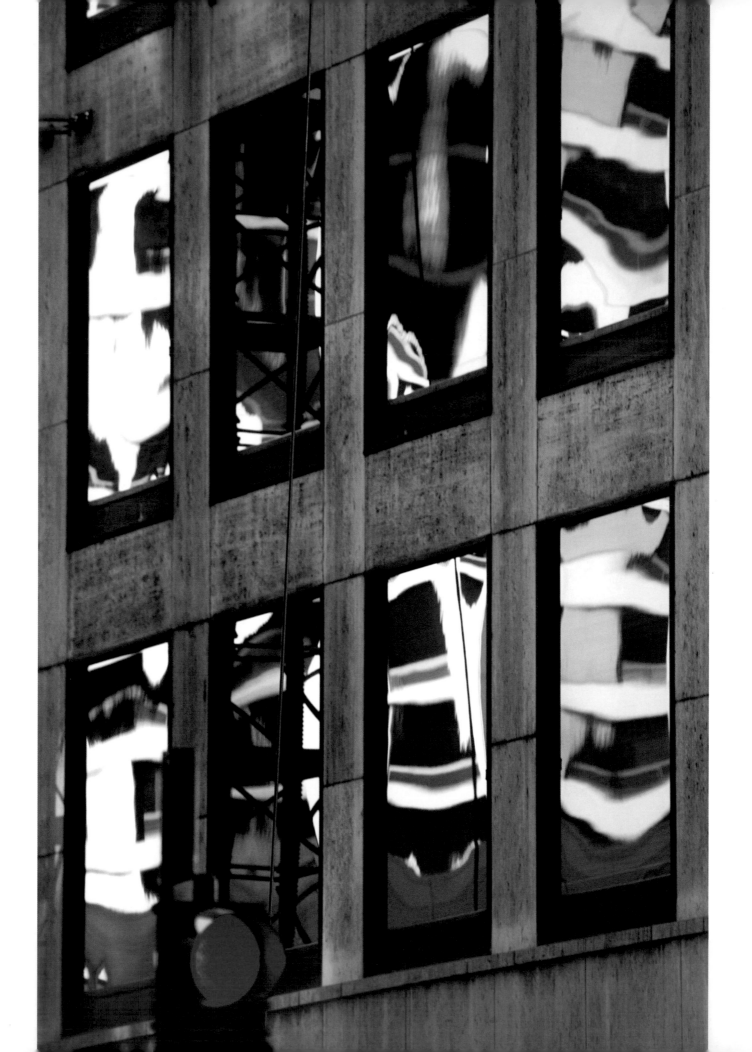

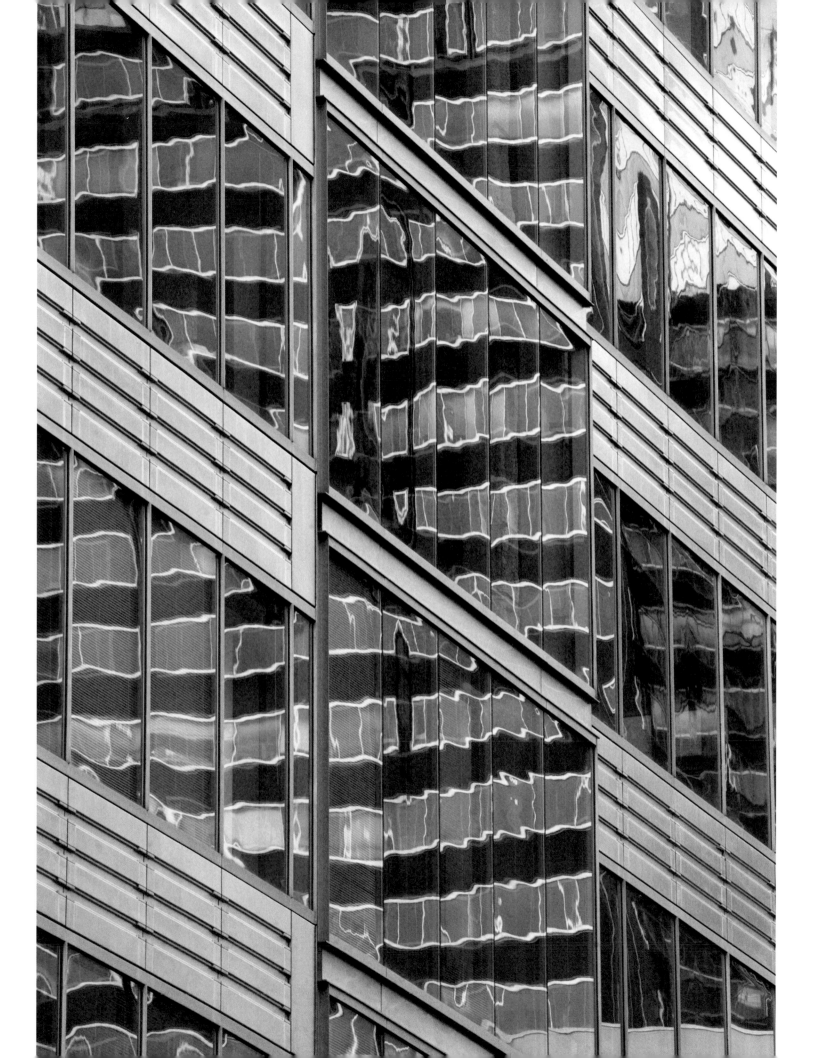

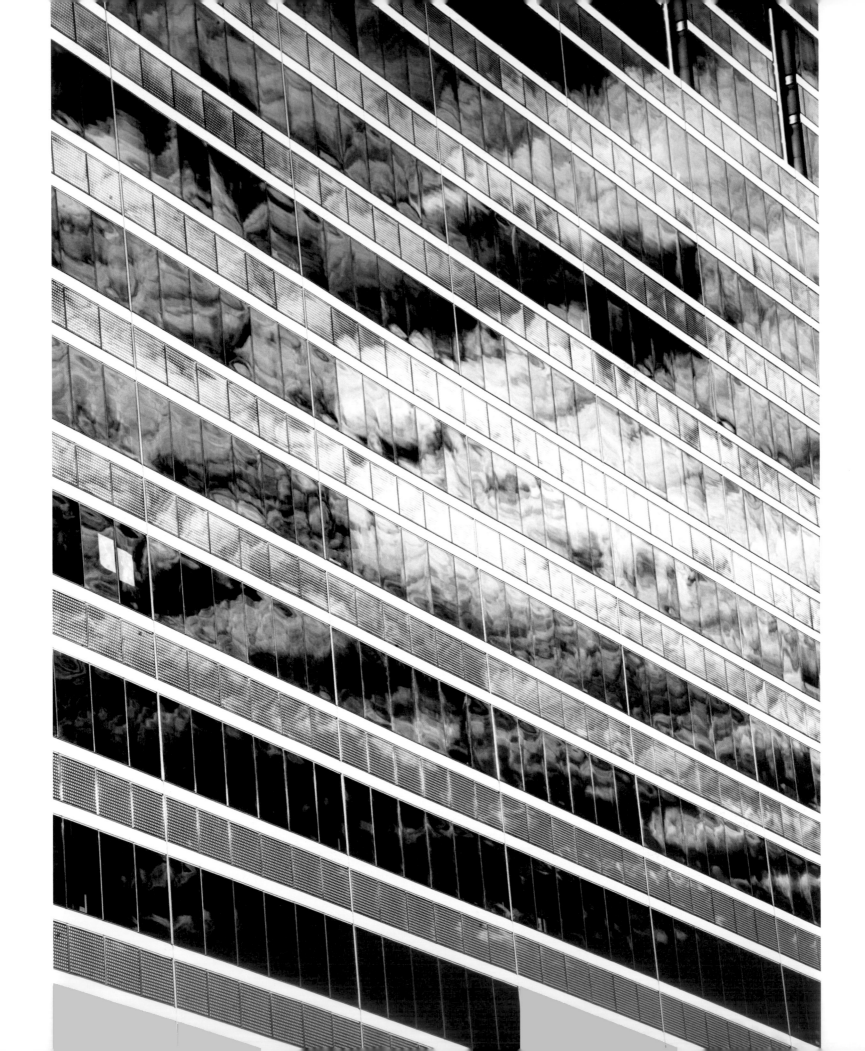

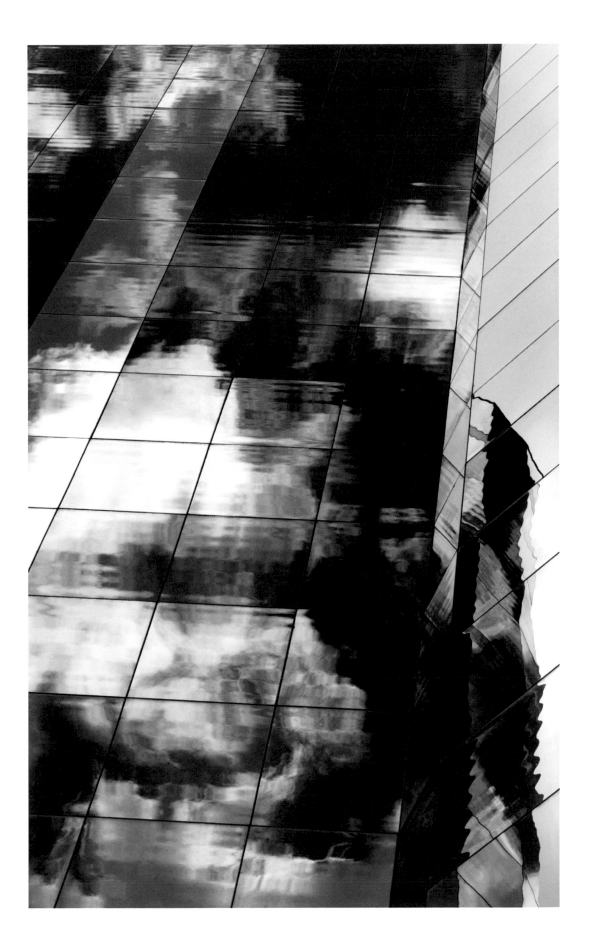

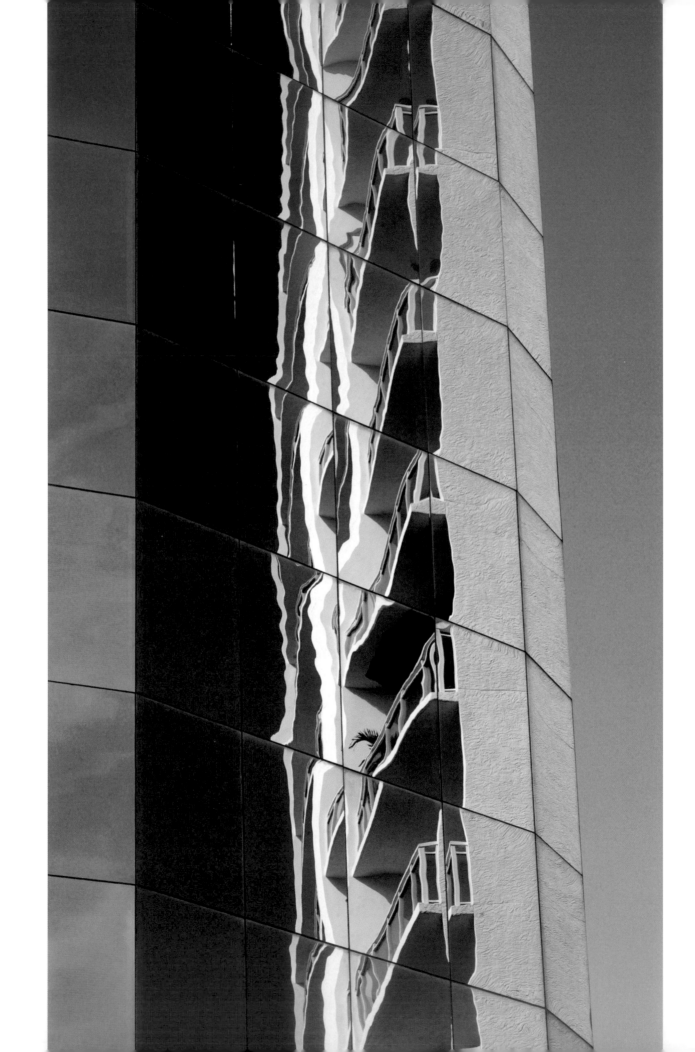

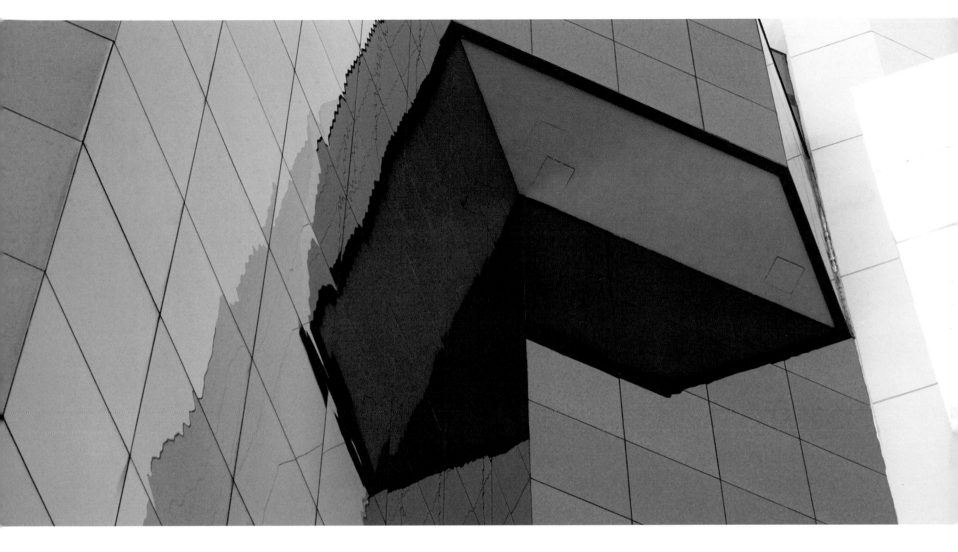

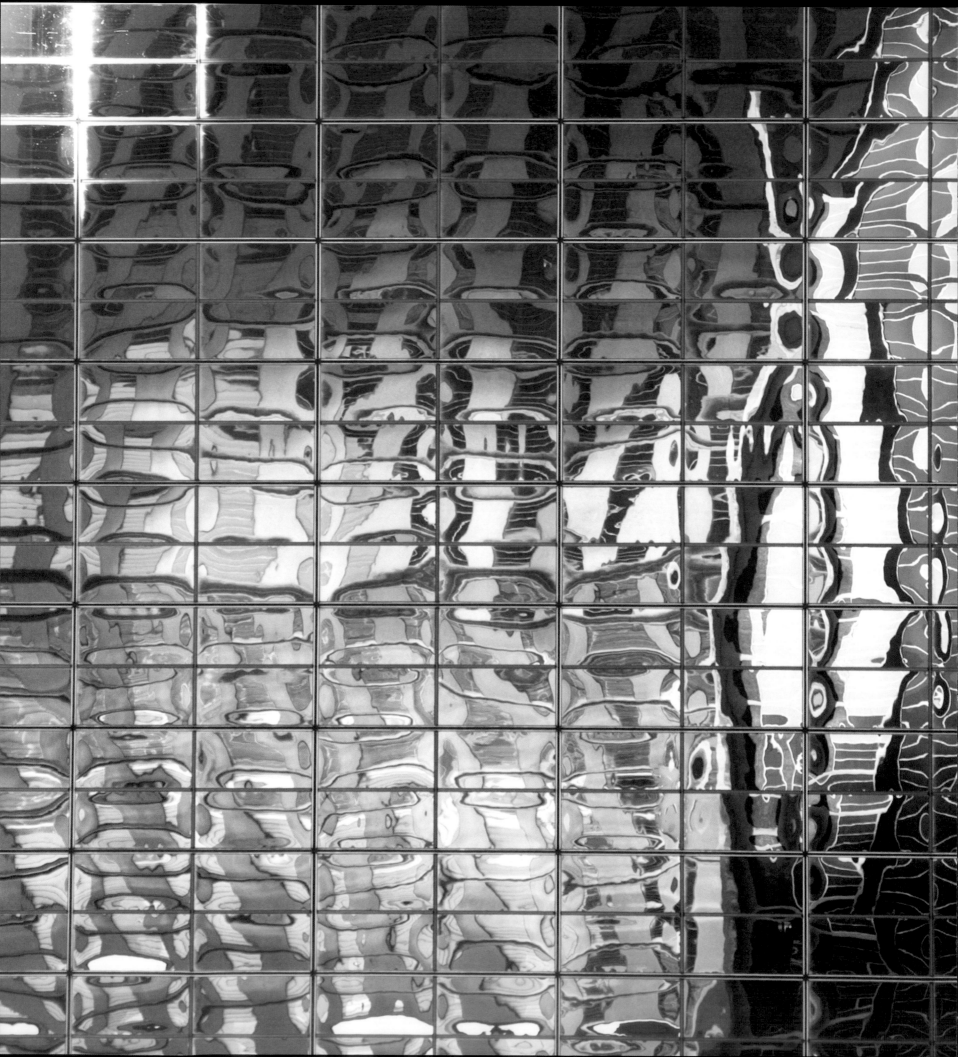

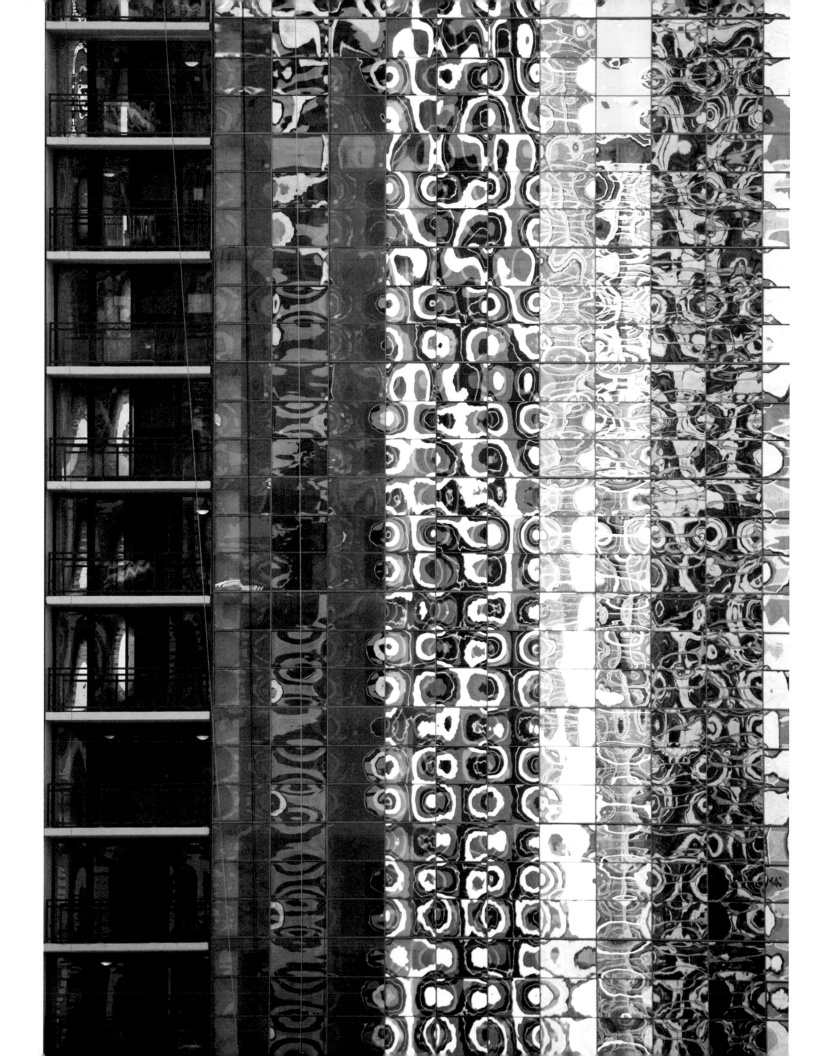

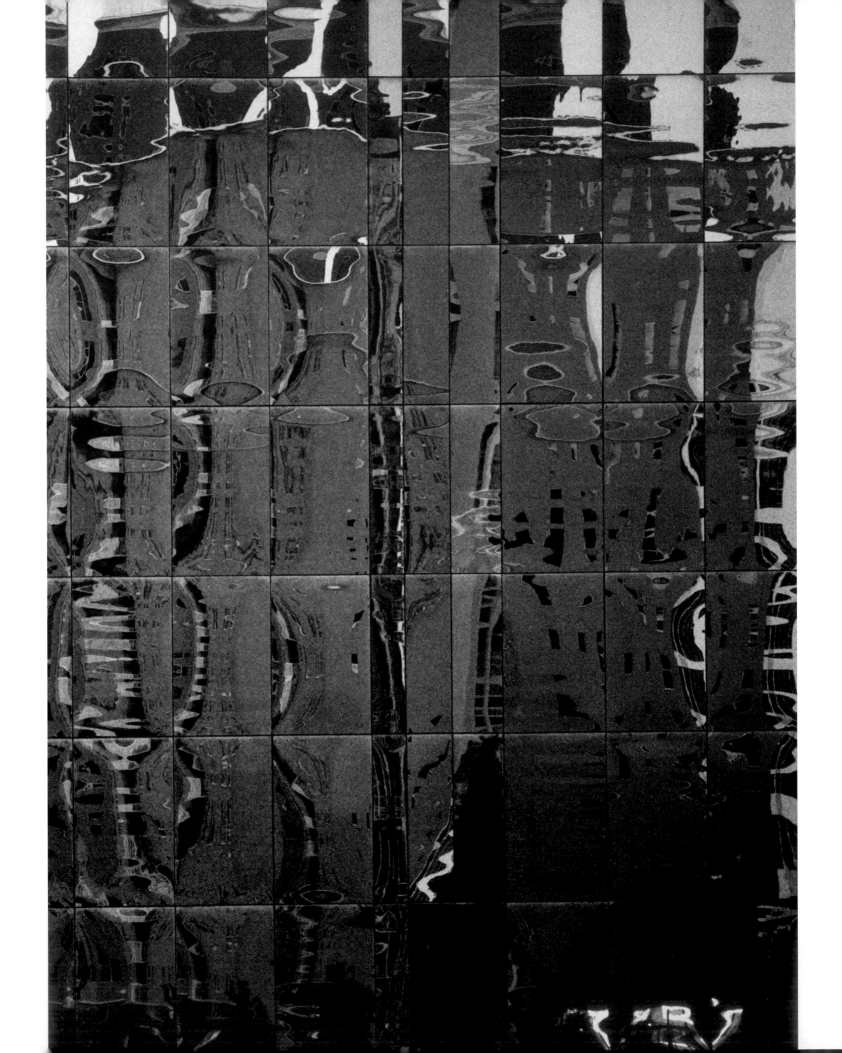

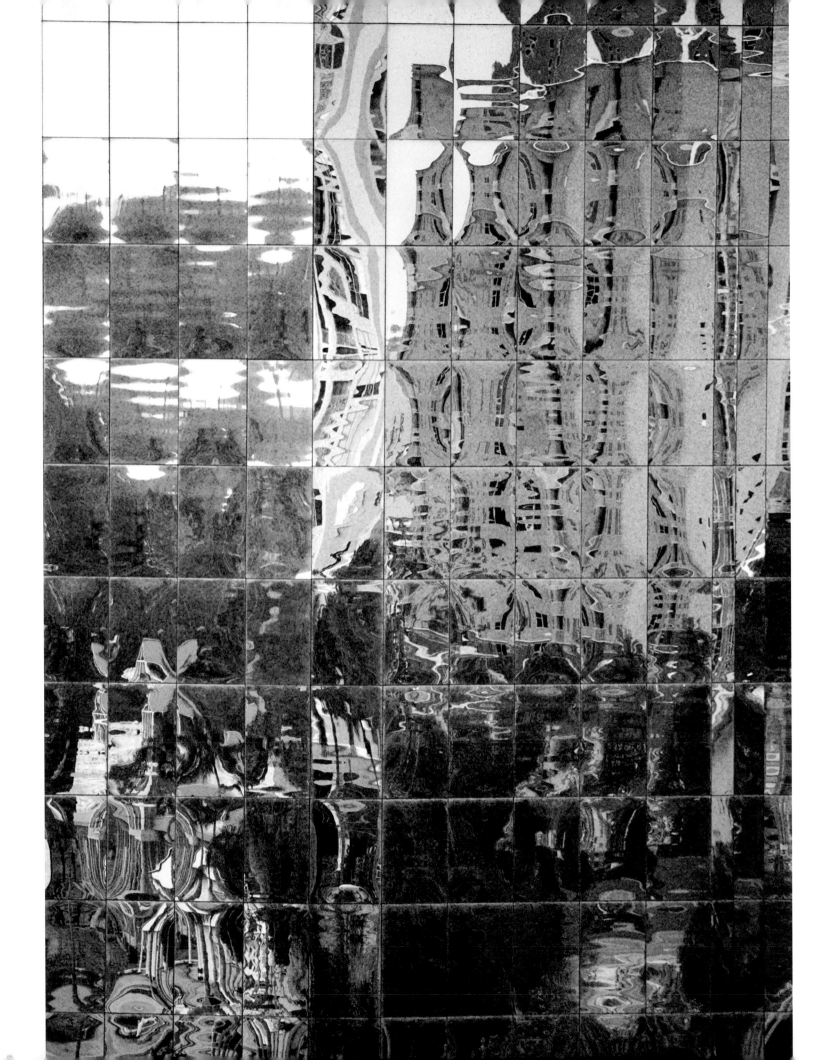

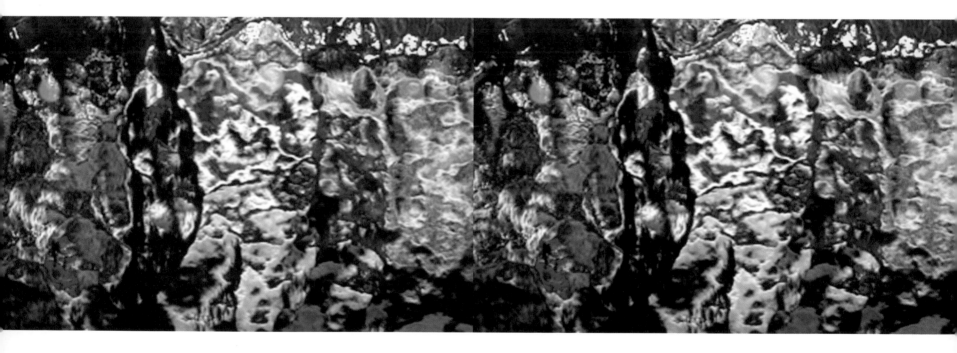

4
Through the Looking Glass

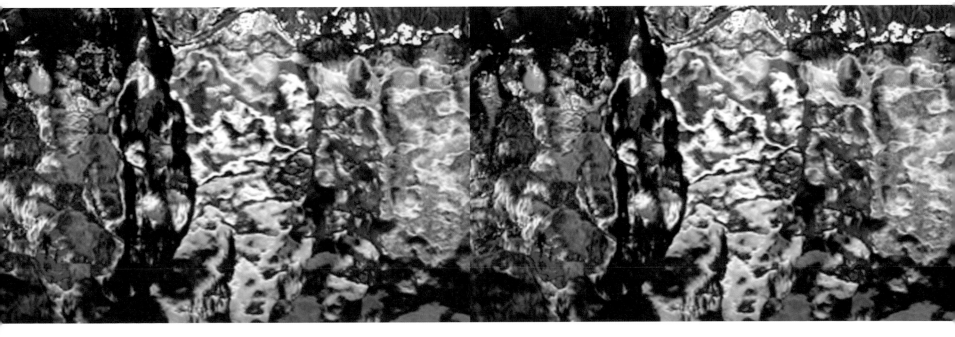

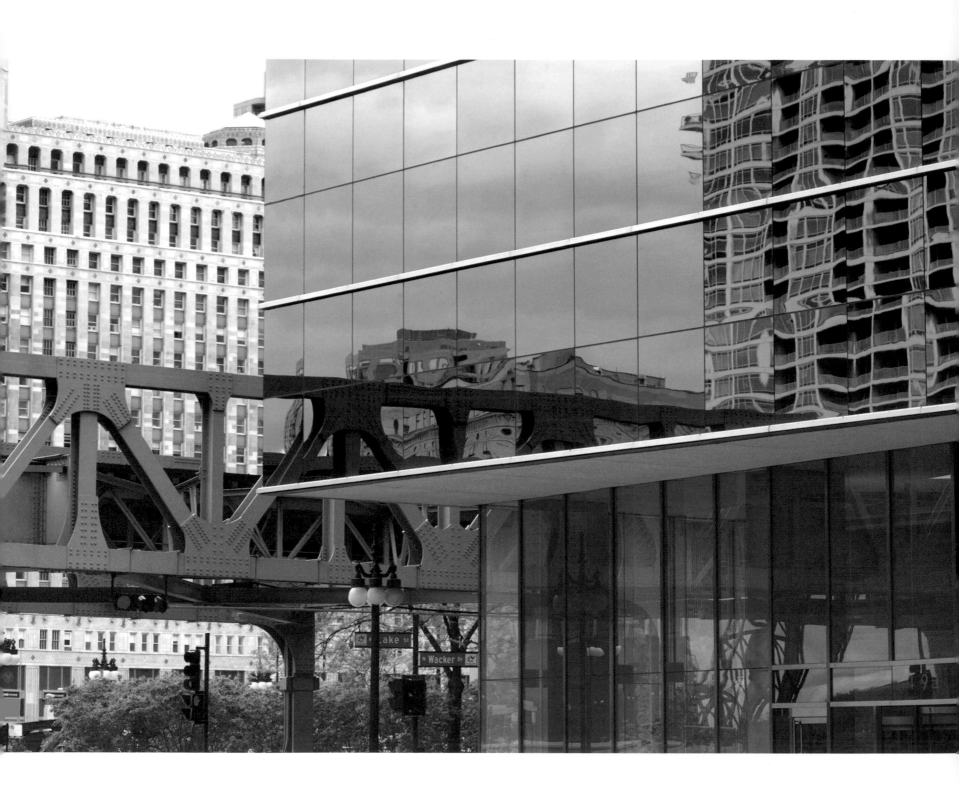

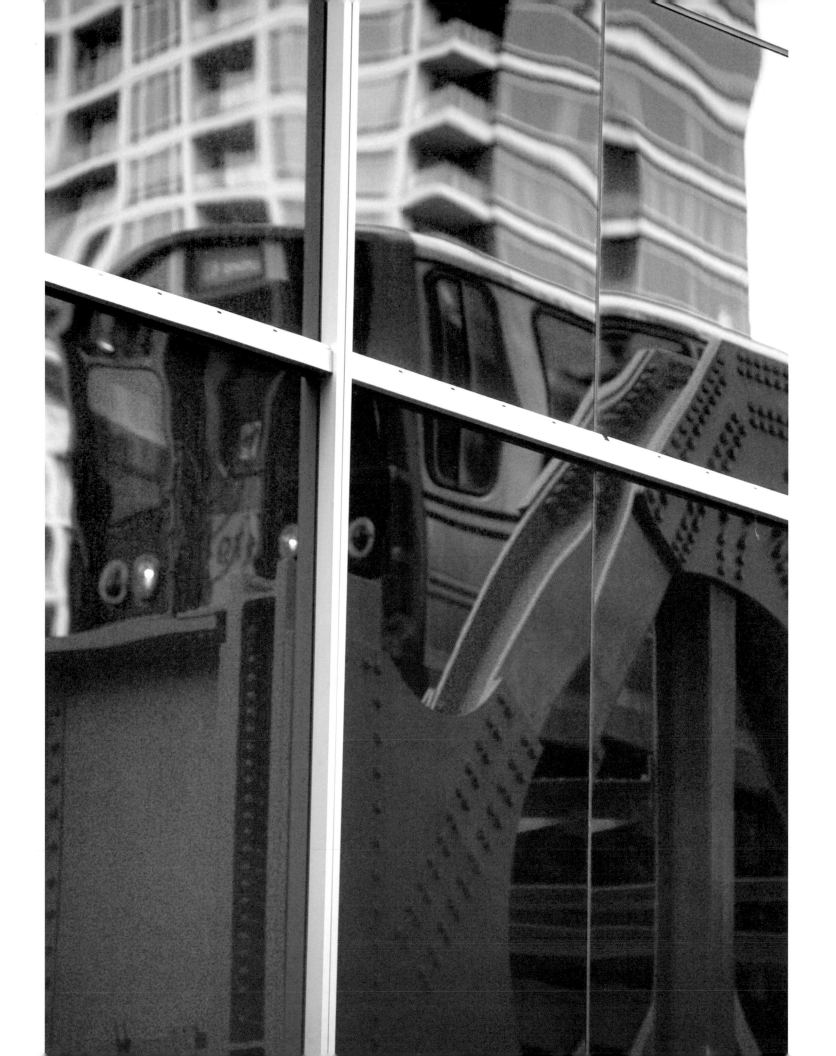

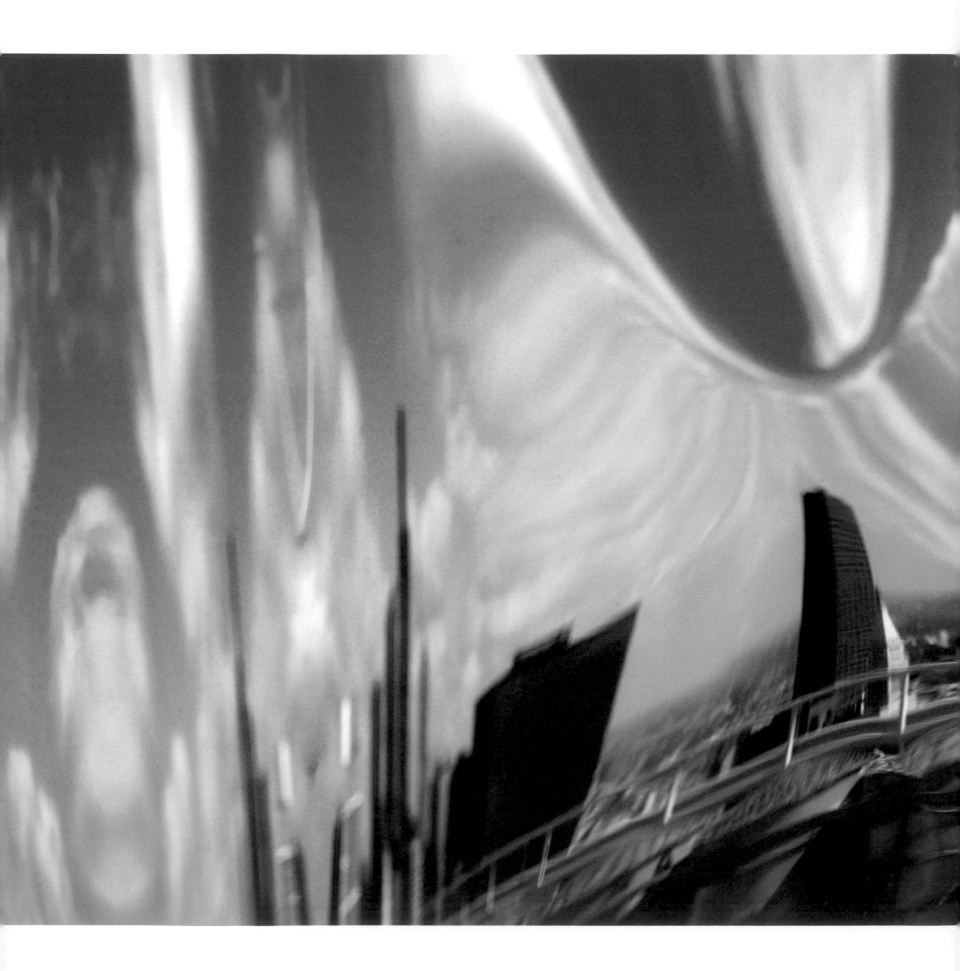

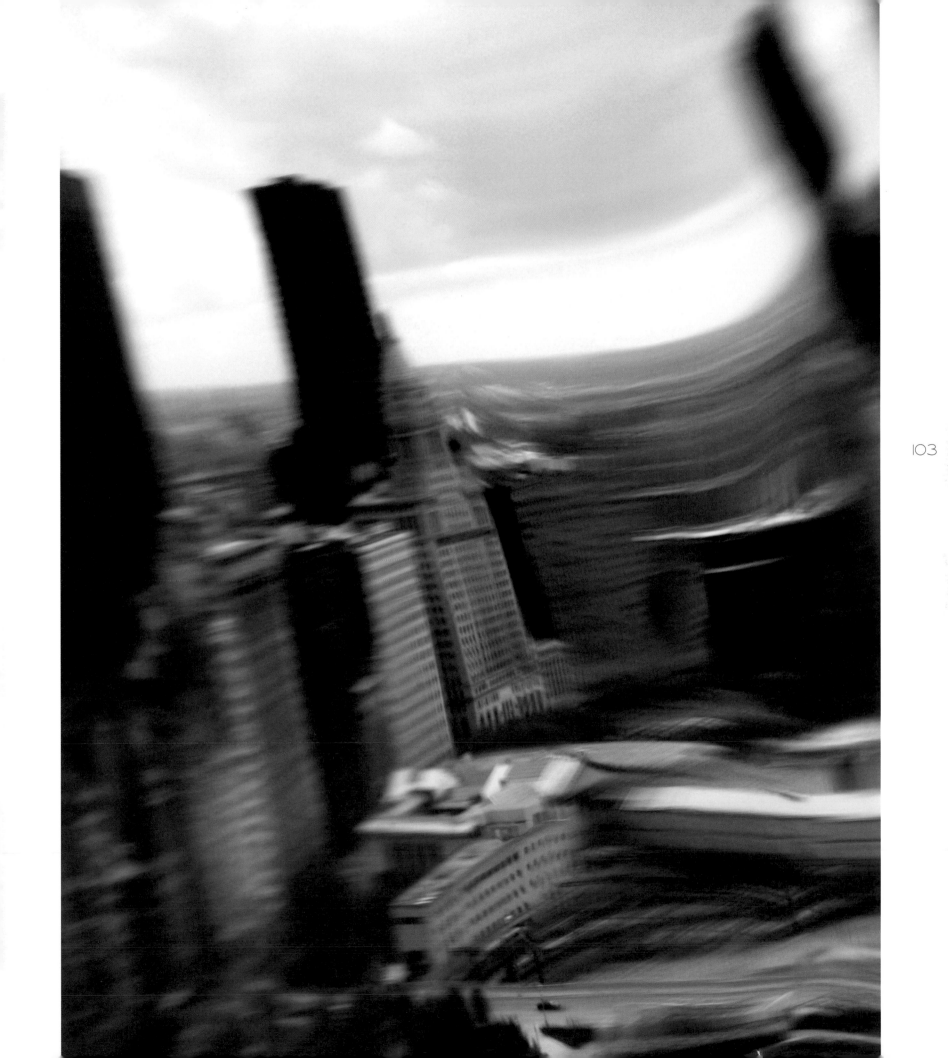

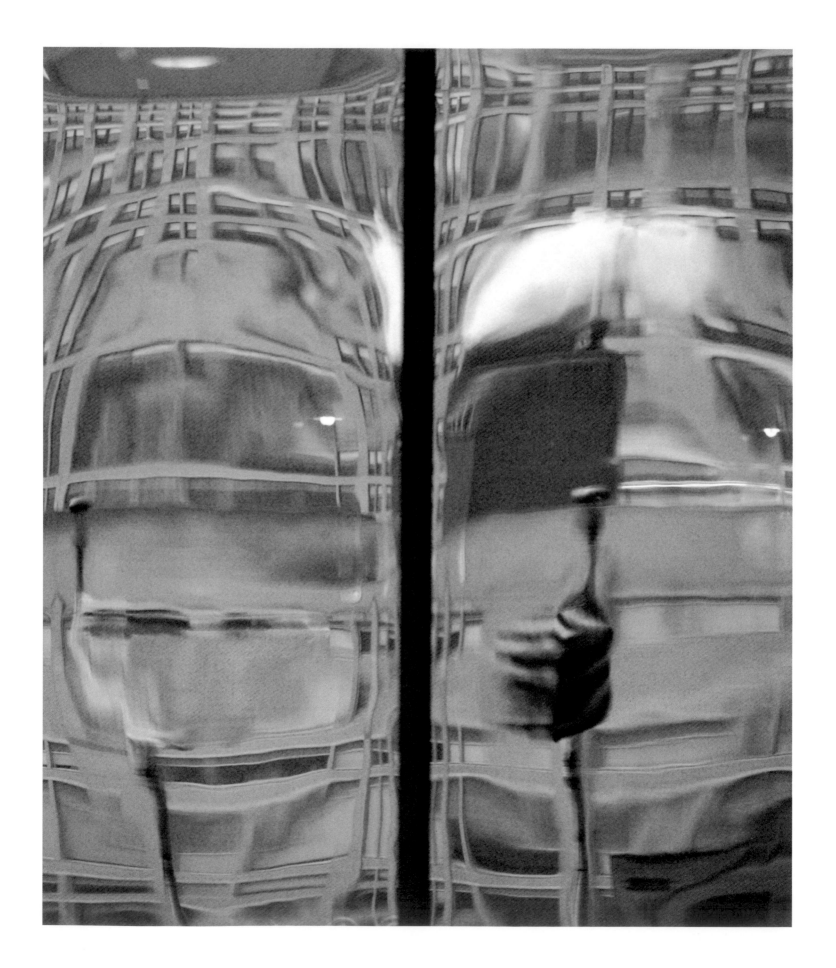

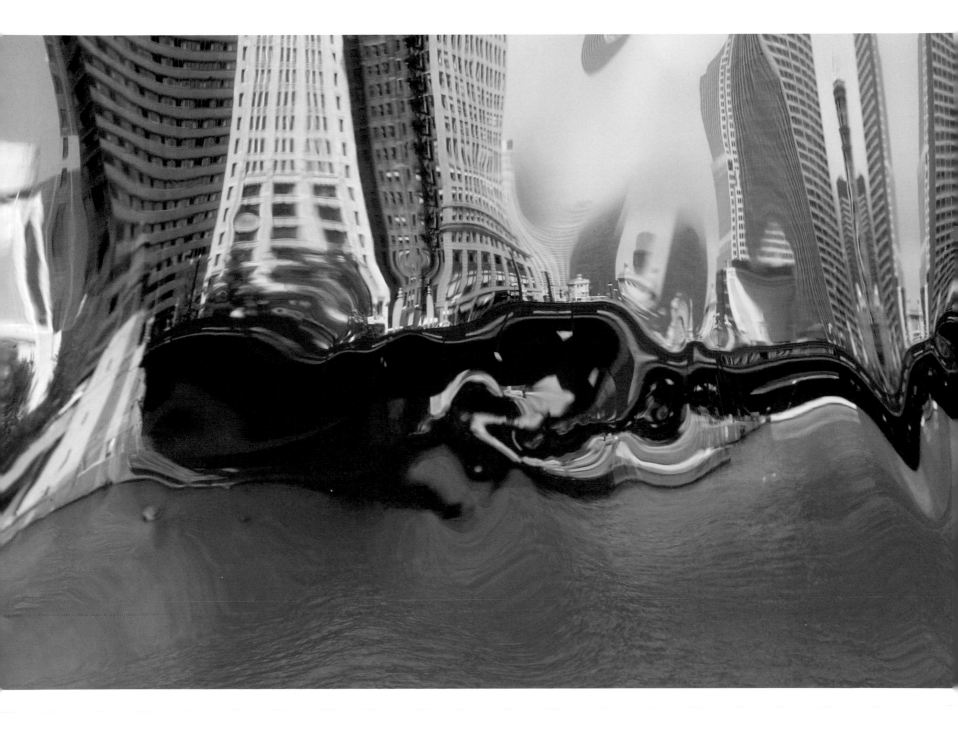

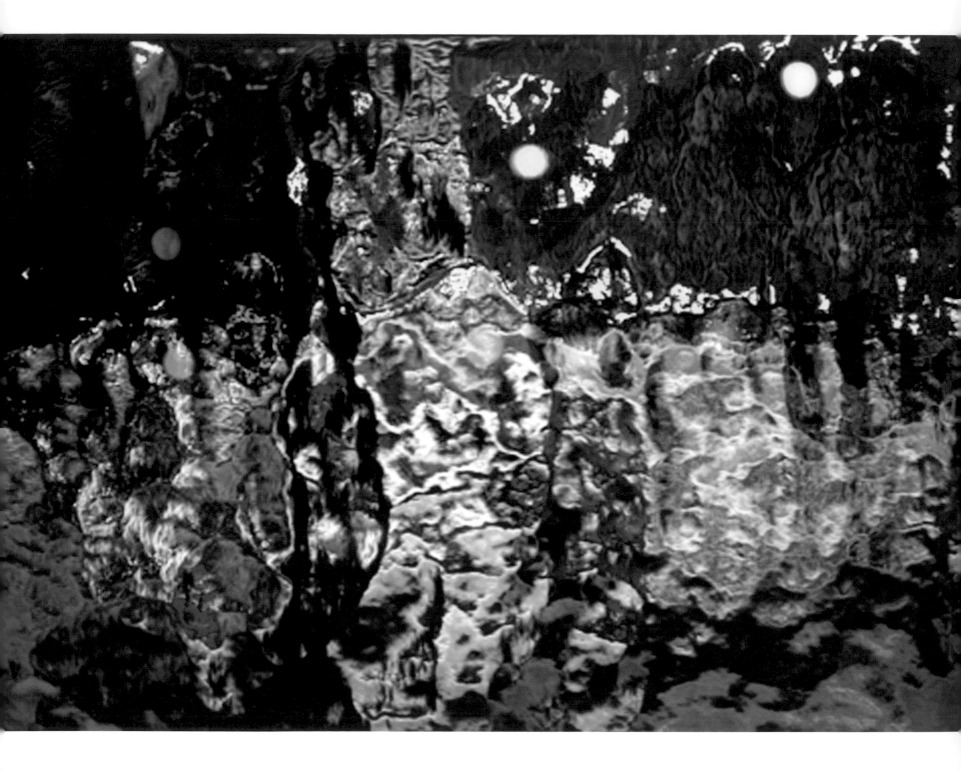

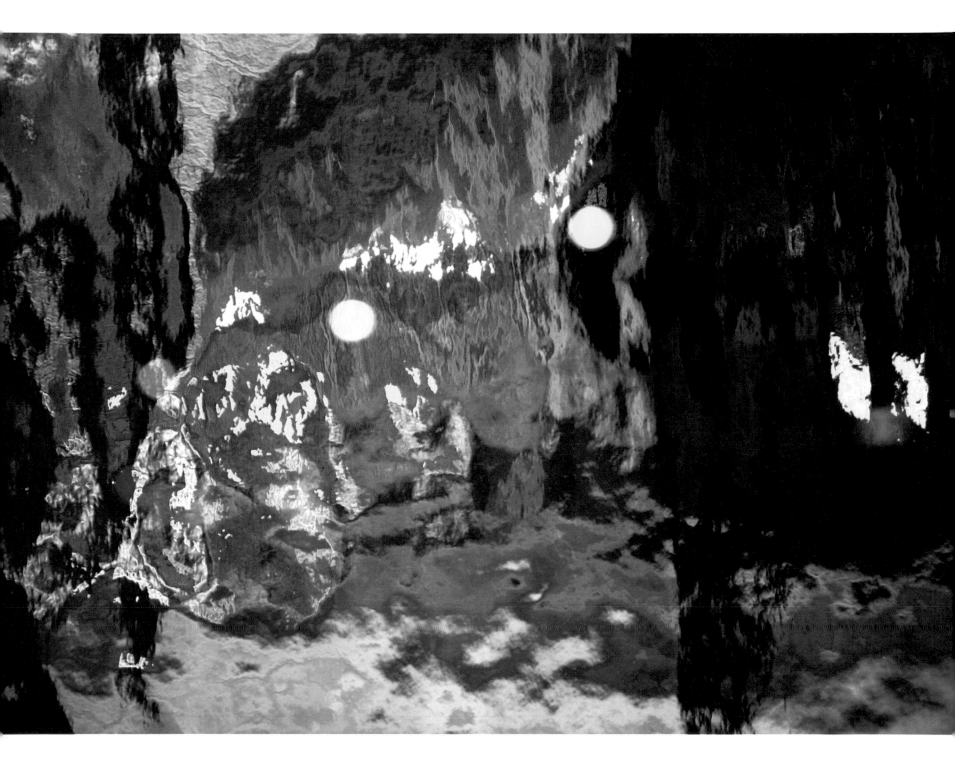

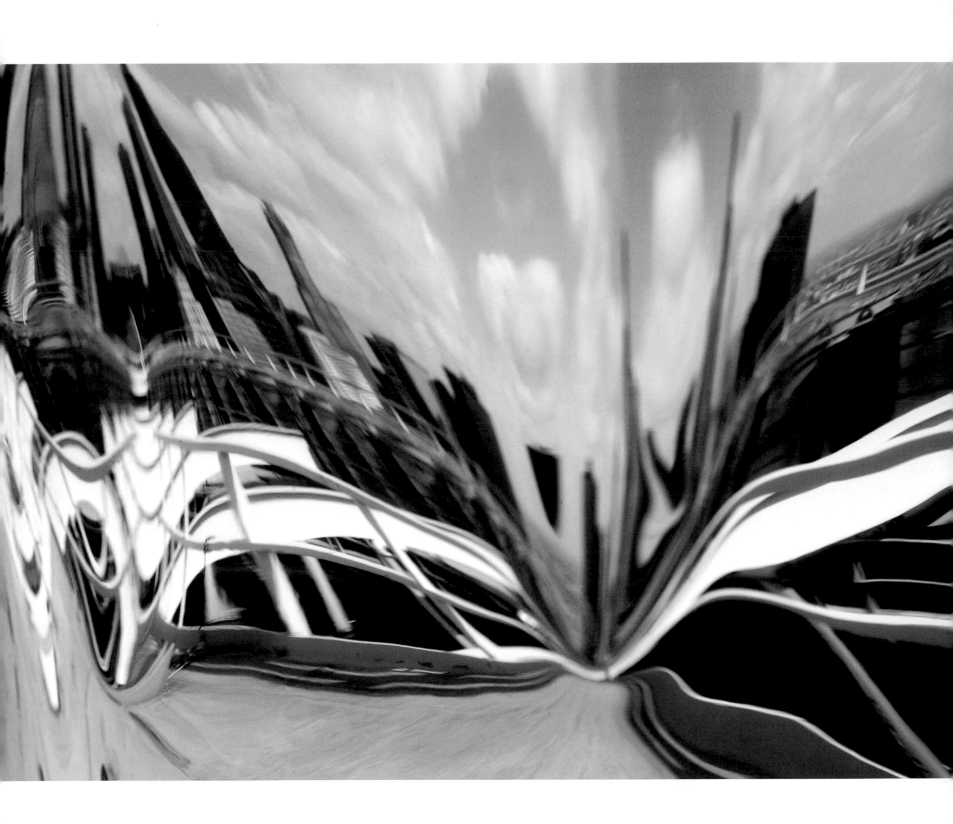

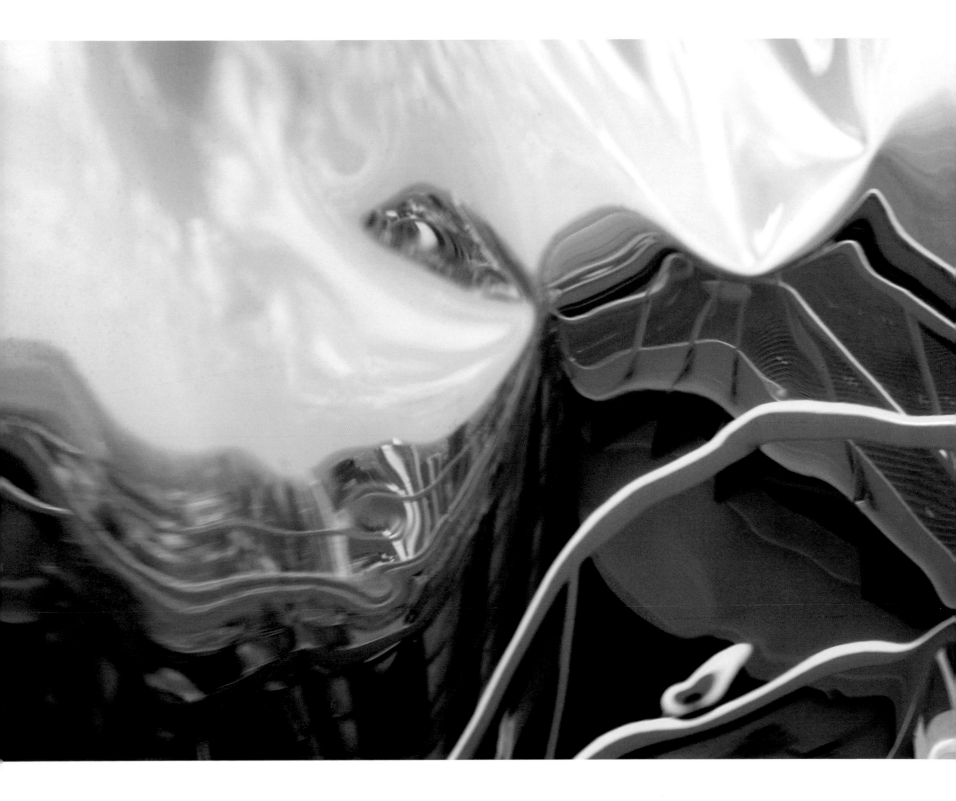

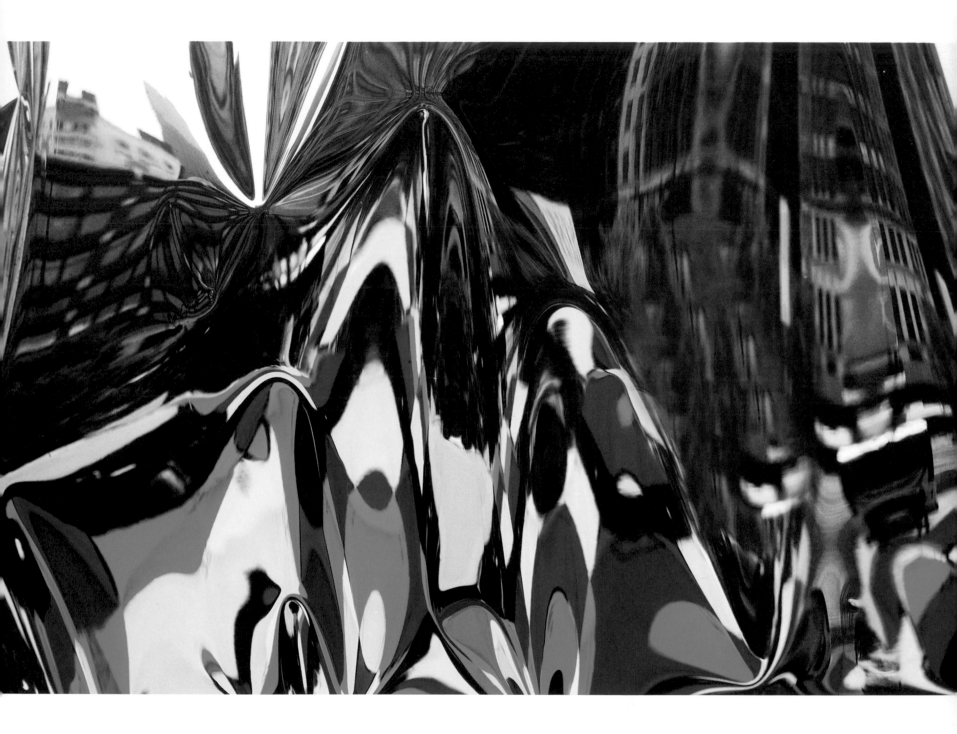

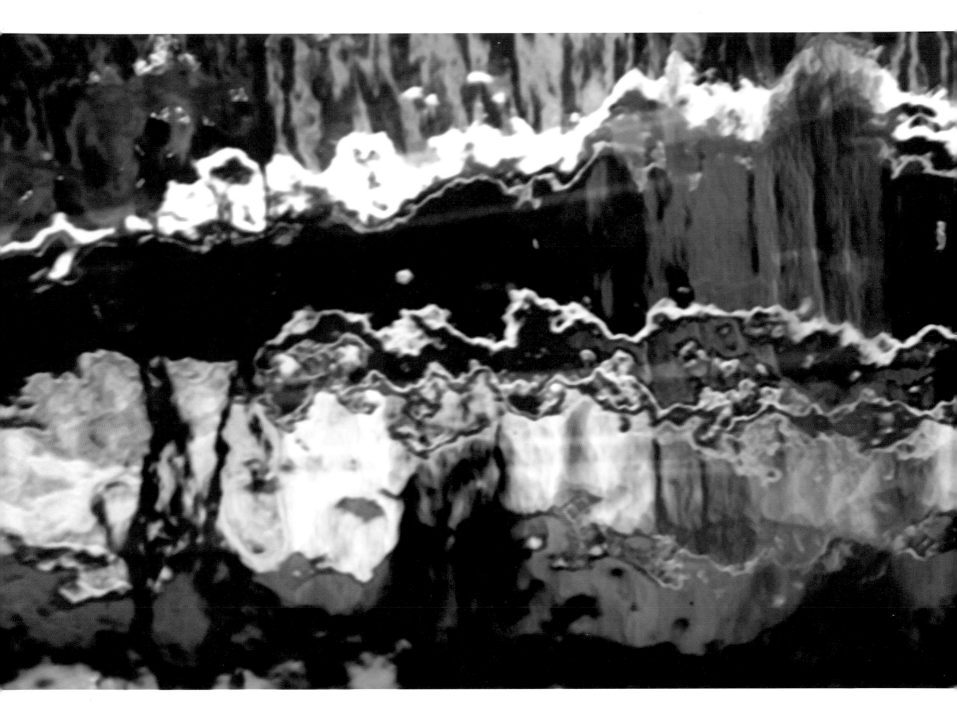

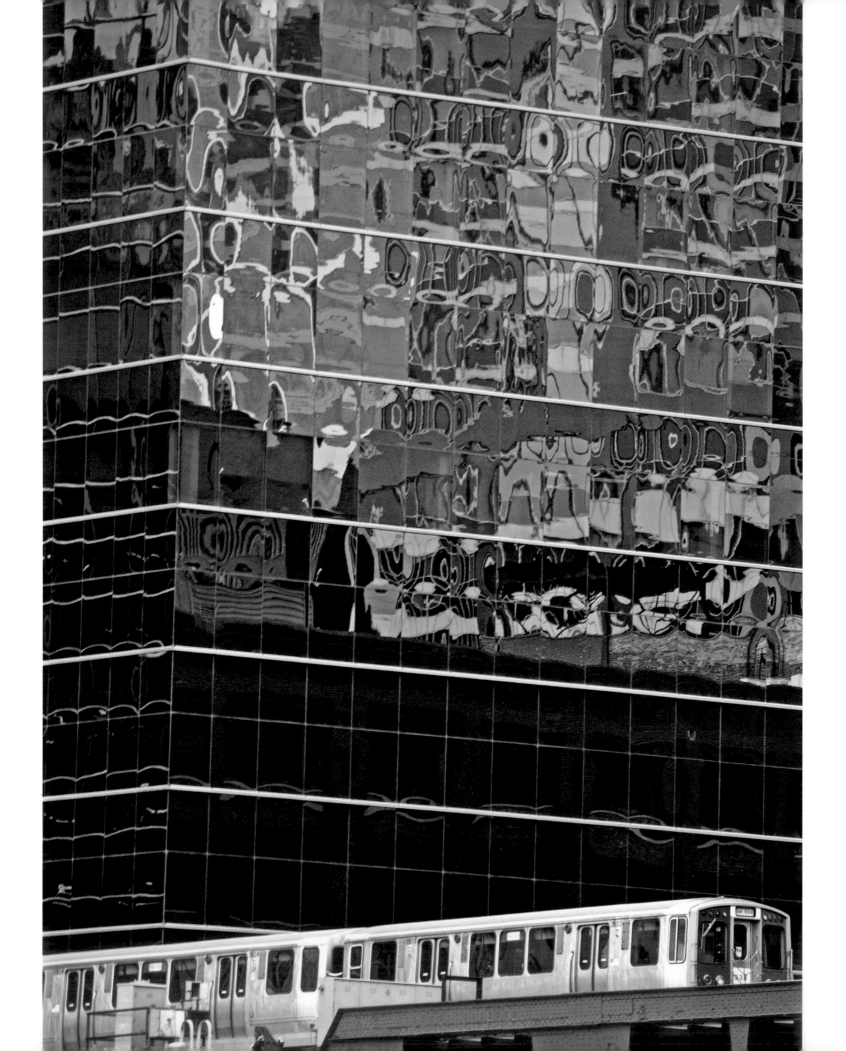

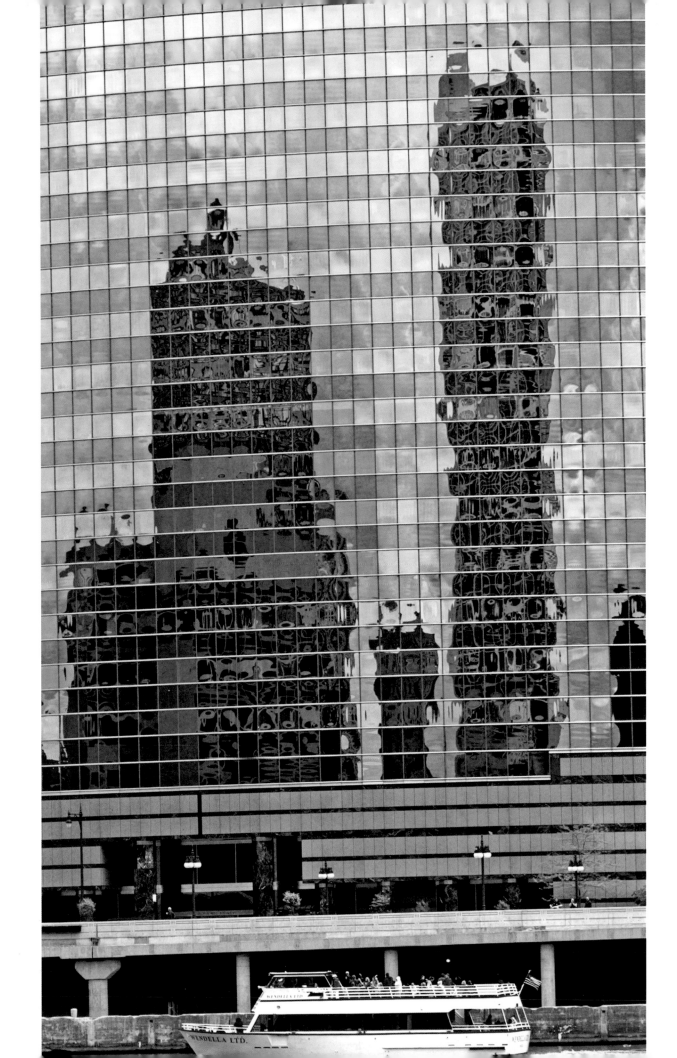

INDEX TO PHOTOGRAPHS

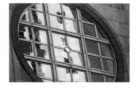
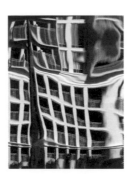
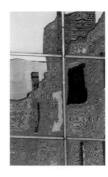
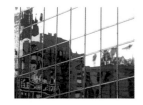
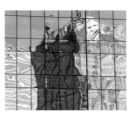
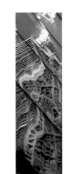
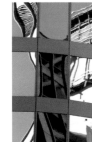
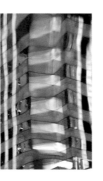

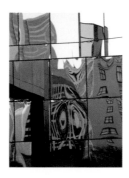
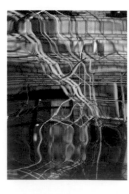
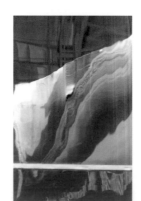

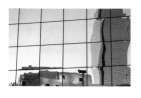

33
Reflections on a City, 41
Dallas, TX
Speed: 1/200 sec.
F stop: f/6.3
ISO: 320
Focal length: 100.0 mm

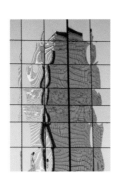

34
Reflections on a City, 45
Dallas, TX
Speed: 1/250 sec.
F stop: f/6.3
ISO: 320
Focal length: 135.0 mm

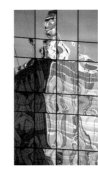

35
Reflections on a City, 55
Dallas, TX
Speed: 1/320 sec.
F stop: f/5.6
ISO: 160
Focal length: 300.0 mm

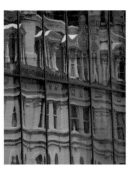

36
Reflections on a City, 138
Milwaukee, WI
Speed: 1/250 sec.
F stop: f/5.6
ISO: 100
Focal length: 250.0 mm

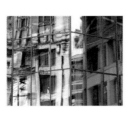

37
Reflections on a City, 139
Milwaukee, WI
Speed: 1/200 sec.
F stop: f/6.3
ISO: 100
Focal length: 100.0 mm

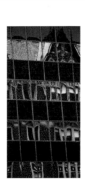

38
Reflections on a City, 143
Milwaukee, WI
Speed: 1/200 sec.
F stop: f/5.0
ISO: 125
Focal length: 220.0 mm

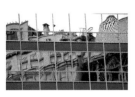

39
Reflections on a City, 142
Milwaukee, WI
Speed: 1/320 sec.
F stop: f/6.3
ISO: 125
Focal length: 260.0 mm

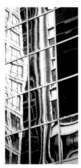

40
Reflections on a City, 132
Chicago, IL
Speed: 1/125 sec.
F stop: f/5.6
ISO: 200
Focal length: 135.0 mm

41 (left)
Reflections on a City, 24
Chicago, IL
Speed: 1/200 sec.
F stop: f/6.3
ISO: 160
Focal length: 105.0 mm

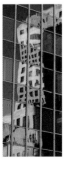

41 (right)
Reflections on a City, 15
Chicago, IL
Speed: 1/200 sec.
F stop: f/6.3
ISO: 320
Focal length: 120.0 mm

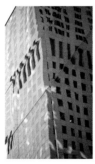

42
Reflections on a City, 68
Chicago, IL
Speed: 1/60 sec.
F stop: f/4.5
ISO: 160
Focal length: 100.0 mm

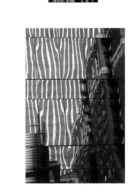

43
Reflections on a City, 153
Chicago, IL
Speed: 1/400 sec.
F stop: f/10.0
ISO: 500
Focal length: 150.0 mm

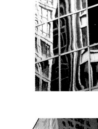

44
Reflections on a City, 5
Chicago, IL
Speed: 1/500 sec.
F stop: f/8.0
ISO: 500
Focal length: 260.0 mm

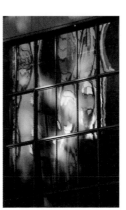

45
Reflections on a City, 9
Chicago, IL
Speed: 1/320 sec.
F stop: f/7.1
ISO: 500
Focal length: 190.0 mm

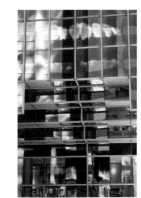

46
Reflections on a City, 161
Chicago, IL
Speed: 1/40 sec.
F stop: f/4.5
ISO: 100
Focal length: 56.0 mm

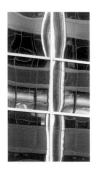

47
Reflections on a City, 25
Chicago, IL
Speed: 1/25 sec.
F stop: f/4.5
ISO: 200
Focal length: 120.0 mm

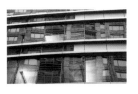

48
Reflections on a City, 136
Chicago, IL
Speed: 1/60 sec.
F stop: f/5.6
ISO: 320
Focal length: 90.0 mm

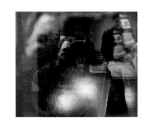

49
Reflections on a City, 15
Chicago, IL
Speed: 1/100 sec.
F stop: f/5.6
ISO: 125
Focal length: 260.0 mm

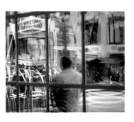

52
Reflections on a City, 3
Chicago, IL
Speed: 1/30 sec.
F stop: f/5.6
ISO: 320
Focal length: 122.0 mm

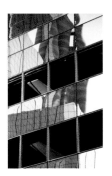

53
Reflections on a City, 6
Chicago, IL
Speed: 1/400 sec.
F stop: f/7.1
ISO: 320
Focal length: 285.0 mm

54
Reflections on a City, 5
Chicago, IL
Speed: 1/20 sec.
F stop: f/5.6
ISO: 800
Focal length: 135.0 mm

55
Reflections on a City, 174
Chicago, IL
Speed: 1/8 sec.
F stop: f/5.6
ISO: 160
Focal length: 90.0 mm

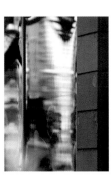

56
Reflections on a City, 38
Dallas, TX
Speed: 1/100 sec.
F stop: f/4.5
ISO: 320
Focal length: 100.0 mm

57
Reflections on a City, 3
Dallas, TX
Speed: 1/125 sec.
F stop: f/5.6
ISO: 500
Focal length: 300.0 mm

58
Reflections on a City, 42
Dallas, TX
Speed: 1/60 sec.
F stop: f/5.6
ISO: 320
Focal length: 300.0 mm

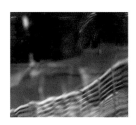

59
Reflections on a City, 118
Chicago, IL
Speed: 1/1000 sec.
F stop: f/11.0
ISO: 640
Focal length: 400.0 mm

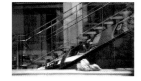

60
Reflections on a City, 15
Madison, WI
Speed: 1/125 sec.
F stop: f/5.0
ISO: 125
Focal length: 110.0 mm

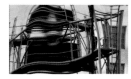

61
Reflections on a City, 18
Chicago, IL
Speed: 1/200 sec.
F stop: f/5.6
ISO: 320
Focal length: 260.0 mm

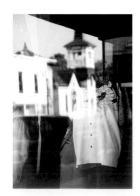

62
Reflections on a City, 161
Elkhorn, WI
Speed: 1/160 sec.
F stop: f/5.6
ISO: 200
Focal length: 100.0 mm

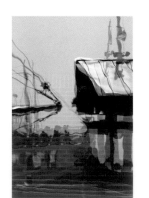

63
Reflections on a City, 12
Chicago, IL
Speed: 1/800 sec.
F stop: f/10.0
ISO: 640
Focal length: 235.0 mm

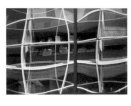

64
Reflections on a City, 114
Chicago, IL
Speed: 1/320 sec.
F stop: f/10.0
ISO: 640
Focal length: 90.0 mm

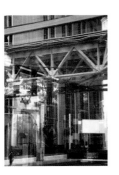

65
Reflections on a City, 137
Chicago, IL
Speed: 1/40 sec.
F stop: f/5.0
ISO: 200
Focal length: 80.0 mm

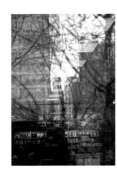

66
Reflections on a City, 60
Chicago, IL
Speed: 1/60 sec.
F stop: f/6.3
ISO: 800
Focal length: 135.0 mm

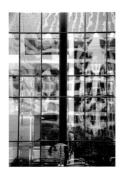

67
Reflections on a City, 134
Chicago, IL
Speed: 1/40 sec.
F stop: f/5.6
ISO: 200
Focal length: 135.0 mm

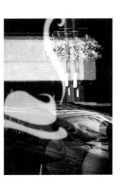

68
Reflections on a City, 150
Elkhorn, WI
Speed: 1/100 sec.
F stop: f/4.5
ISO: 125
Focal length: 100.0 mm

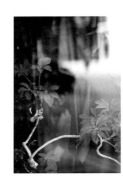

69
Reflections on a City, 158
Elkhorn, WI
Speed: 1/125 sec.
F stop: f/5.0
ISO: 200
Focal length: 150.0 mm

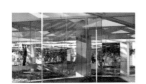

70
Reflections on a City, 35
Dallas, TX
Speed: 1/125 sec.
F stop: f/5.0
ISO: 160
Focal length: 100.0 mm

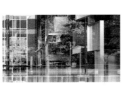

71
Reflections on a City, 14
Chicago, IL
Speed: 1/40 sec.
F stop: f/4.5
ISO: 200
Focal length: 120.0 m

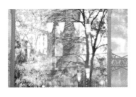

72
Reflections on a City, 173
Chicago, IL
Speed: 1/100 sec.
F stop: f/4.0
ISO: 400
Focal length: 195.0 mm

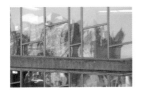

73
Reflections on a City, 171
Chicago, IL
Speed: 1/400 sec.
F stop: f/6.3
ISO: 500
Focal length: 250.0 mm

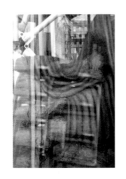

74
Reflections on a City, 113
Chicago, IL
Speed: 1/400 sec.
F stop: f/10.0
ISO: 640
Focal length: 135.0 mm

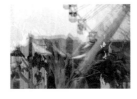

75
Reflections on a City, 115
Chicago, IL
Speed: 1/400 sec.
F stop: f/11.0
ISO: 640
Focal length: 90.0 mm

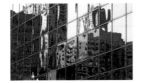

78
Reflections on a City, 73
Chicago, IL
Speed: 1/400 sec.
F stop: f/8.0
ISO: 500
Focal length: 150.0 mm

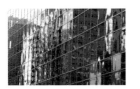

79
Reflections on a City, 74
Chicago, IL
Speed: 1/320 sec.
F stop: f/7.1
ISO: 500
Focal length: 150.0 mm

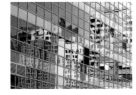

80
Reflections on a City, 26
Chicago, IL
Speed: 1/400 sec.
F stop: f/9.0
ISO: 500
Focal length: 115.0 mm

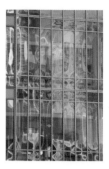

81
Reflections on a City, 172
Chicago, IL
Speed: 1/200 sec.
F stop: f/5.6
ISO: 160
Focal length: 190.0 mm

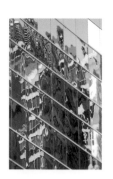

82
Reflections on a City, 11
Chicago, IL
Speed: 1/500 sec.
F stop: f/8.0
ISO: 500
Focal length: 400.0 mm

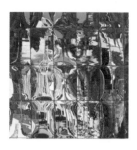

83
Reflections on a City, 8
Sarasota, FL
Speed: 1/400 sec.
F stop: f/7.1
ISO: 125
Focal length: 400.0 mm

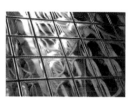

84
Reflections on a City, 103
Chicago, IL
Speed: 1/15 sec.
F stop: f/5.0
ISO: 800
Focal length: 65.0 mm

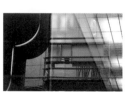

85
Reflections on a City, 101
Chicago, IL
Speed: 1/85 sec.
F stop: f/4.5
ISO: 500
Focal length: 115.0 mm

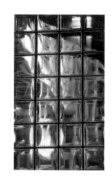

86
Reflections on a City, 9
Chicago, IL
Speed: 1/40 sec.
F stop: f/5.0
ISO: 640
Focal length: 150.0 mm

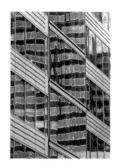

87
Reflections on a City, 108
Chicago, IL
Speed: 1/60 sec.
F stop: f/5.0
ISO: 640
Focal length: 150.0 mm

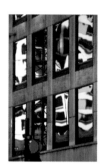

88
Reflections on a City, 12
Chicago, IL
Speed: 1/200 sec.
F stop: f/5.6
ISO: 320
Focal length: 285.0 mm

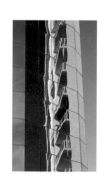

89
Reflections on a City, 10
Chicago, IL
Speed: 1/640 sec.
F stop: f/9.0
ISO: 800
Focal length: 210.0 mm

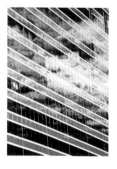

90
Reflections on a City, 7
Chicago, IL
Speed: 1/1000 sec.
F stop: f/14.0
ISO: 320
Focal length: 135.0 mm

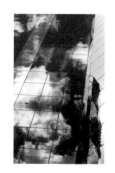

91
Reflections on a City, 94
Sarasota, FL
Speed: 1/800 sec.
F stop: f/13.0
ISO: 400
Focal length: 100.0 mm

92
Reflections on a City, 89
Sarasota, FL
Speed: 1/640 sec.
F stop: f/13
ISO: 250
Focal length: 100.0 mm

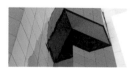

93
Reflections on a City, 92
Sarasota, FL
Speed: 1/500 sec.
F stop: f/10.0
ISO: 640
Focal length: 100.0 mm

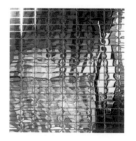

94
Reflections on a City, 40
Dallas, TX
Speed: 1/400 sec.
F stop: f/6.3
ISO: 500
Focal length: 250.0 mm

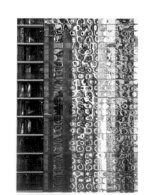

95
Reflections on a City, 1
Chicago, IL
Speed: 1/500 sec.
F stop: f/8.0
ISO: 320
Focal length: 400.0 mm

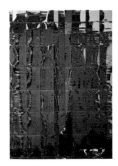

96
Reflections on a City, 90
Sarasota, FL
Speed: 1/250 sec.
F stop: f/5.6
ISO: 1000
Focal length: 400.0 mm

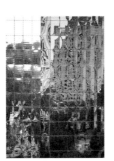

97
Reflections on a City, 93
Sarasota, FL
Speed: 1/320 sec.
F stop: f/6.3
ISO: 800
Focal length: 400.0 mm

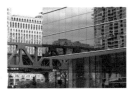

100
Reflections on a City, 130
Chicago, IL
Speed: 1/250 sec.
F stop: f/7.1
ISO: 200
Focal length: 105.0 mm

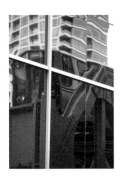

101
Reflections on a City, 135
Chicago, IL
Speed: 1/160 sec.
F stop: f/5.6
ISO: 320
Focal length: 260.0 mm

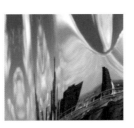

102
Reflections on a City, 145
Chicago, IL
Speed: 1/400 sec.
F stop: f/11.0
ISO: 100
Focal length: 65.0 mm

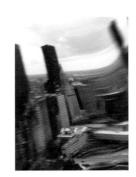

103
Reflections on a City, 149
Chicago, IL
Speed: 1/200 sec.
F stop: f/8.0
ISO: 160
Focal length: 80.0 mm

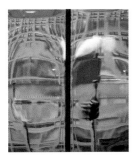

104
Reflections on a City, 106
Chicago, IL
Speed: 1/500 sec.
F stop: f/8.0
ISO: 800
Focal length: 400.0 mm

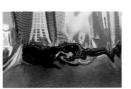

105
Reflections on a City, 154
Chicago, IL
Speed: 1/500 sec.
F stop: f/14.0
ISO: 500
Focal length: 50.0 mm

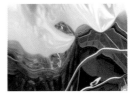

106
Reflections on a City, 162
Chicago, IL
Speed: 1/100 sec.
F stop: f/5.6
ISO: 400
Focal length: 135.0 mm

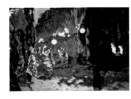

107
Reflections on a City, 164
Chicago, IL
Speed: 1/50 sec.
F stop: f/5.6
ISO: 400
Focal length: 109.0 mm

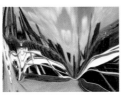

108
Reflections on a City, 146
Chicago, IL
Speed: 1/320 sec.
F stop: f/11.0
ISO: 100
Focal length: 65.0 mm

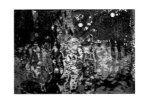

109
Reflections on a City, 148
Chicago, IL
Speed: 1/320 sec.
F stop: f/10.0
ISO: 100
Focal length: 65.0 mm

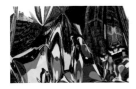

110
Reflections on a City, 157
Chicago, IL
Speed: 1/400 sec.
F stop: f/11.0
ISO: 160
Focal length: 65.0 mm

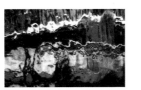

111
Reflections on a City, 165
Chicago, IL
Speed: 1/8 sec.
F stop: f/18.0
ISO: 400
Focal length: 95.0 mm

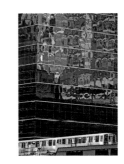

112
Reflections on a City, 126
Chicago, IL
Speed: 1/160 sec.
F stop: f/5.6
ISO: 200
Focal length: 275.0 mm

113
Reflections on a City, 124
Chicago, IL
Speed: 1/250 sec.
F stop: f/7.1
ISO: 200
Focal length: 100.0 mm